W9-CHL-937

PROMOTING
&
SELLING
YOUR ART

PROMOTING & SELLING YOUR ART

BY CAROLE KATCHEN

WATSON-GUPTILL PUBLICATIONS/NEW YORK

*I dedicate this book with love to Florence Crannell Means,
author, whose courage is my guide and inspiration.*

Copyright © 1978 by Watson-Guptill Publications

First published 1978 in New York by Watson-Guptill Publications,
a division of Billboard Publications, Inc.,
1515 Broadway, New York, N.Y. 10036

Library of Congress Cataloging in Publication Data

Katchen, Carole, 1944–
 Promoting and selling your art.

 Includes index.
 1. Art—Marketing. I. Title.
N8600.K37 658.89′7 77–28109
ISBN 0-8230-4422-X

Manufactured in U.S.A.

First Printing, 1978

 4 5 6 7 8 9/86 85 84

ACKNOWLEDGMENTS

To all the people who have generously shared their time and knowledge with me and with all the artists who read this book, I want to say thank you: artists—Gene Boyer, Edgar Britten, Ken Bunn, Tim Cisneros, Libby Cottingham, Doug Dawson, Blaine DeMille, John Eyer, Veryl Goodnight, Ned Jacob, Ramon Kelley, Pawel Kontny, Jackie McFarland, Lee Milmon, Karen Nossaman, Gay Patterson, Alice Plested, Wolf Pogzeba, Bob Ragland, William Sharer, Wally Swank, George Tate, Kent Ullberg, Fritz White, Lori Williamson, Jon Zahourek; collectors—Bob Bucher, Mary Ella Fetzer, Fil Giuliano, Rose Landers, Fred Mikawa, Elaine Penny; dealers—Tom Carson, Jim Fisher, Ed Joseph, Marian Metsopoulos, Phyllis Millenson, Tom Pennington, Paige Reichbart, Sandra Wilson; press people—Katharine Chafee, Irene Clurman, Betty Harvey, John Manson, Beverly Martinez, James Mills, John Neal, John Wolfe.

A very special thank you to Sue Dawson, Sam Katchen, Ed Klamm, and Marsha Melnick.

CONTENTS

INTRODUCTION

About a year ago the art students of Community College of Denver invited me to lecture on drawing and printmaking. During those lectures I found that what most interested the students was not my techniques for creating art, but my experience as a professional artist. They asked: How do you find a gallery? How do you have an exhibit? How do you get your name in the paper? Is it really possible to make a living as an artist?

I thought about how long it had taken me to acquire this information. I thought about the other professional artists I know, and how they have struggled to learn the art business. I began to think that there should be a better way than trial and error, a way in which artists could share their knowledge and save each other some of the frustration of learning to sell art.

At that point I began to work on this book, writing my own experiences and interviewing other artists, dealers, collectors, and press people, to create a practical reference book for artists. I wanted to create a book that would share the basic information necessary to be a professional in the art world.

I decided to focus on the artists of the Denver area, partly because this is where I live and am most familiar with the art community, but also because Denver has a large number of artists who are making a living from their art. By learning to understand the workings of the Denver art world, an artist elsewhere can have a departure point for analyzing his or her own community. The specific collectors, dealers, and press people in Seattle, Dallas, Chicago, Atlanta, are different from those in Denver but their function and general organization are the same.

I have tried to be as specific as possible throughout the book, again to provide a point of reference. I have included times, prices, and names, with the understanding that these will change according to location, date, and situation.

I wrote this book for the art student who is considering an art career, for the amateur artist who is ready to accept the responsibilities of becoming a professional, and for the professional artist who wants to know how someone else has dealt with a particular problem.

My basic premise is that it is possible to make a living as an artist. It takes a tremendous amount of work, both to create salable work and to market that art. Still, being an artist is a viable career. In this book I have not tried to tell anyone how to create their art work; that is a problem each artist has to deal with individually. Rather, I have focused on the promotion and marketing techniques that are necessary for building a career as a professional artist.

CHAPTER 1

CREATING
A PROFESSIONAL
IMAGE

Art is a personal expression of its creator; a work of art can never be completely divorced from the artist. Consequently, the presentation of the artist to the public is a vital part of the presentation of the art itself.

Personal Appearance

Many established artists I know have a unique personal image. There is the eccentric European, the lusty womanizer, the nature-loving recluse. With some artists it is more subtle—a sense of the artist's serious commitment to technique, an artist's love of the subject matter, an artist's aloofness from society. These are characteristics of the artist that are widely recognized in the art community.

It is hard to know if these images are a natural outgrowth of the artist's personality or if they are deliberately assumed roles.

In the art world of the American Southwest there is a unique phenomenon—the western or cowboy artist. The western artist paints and models images of cowboys and Indians, selling them primarily to lovers of the Old West. Some of these artists do serious, high-quality work; others mass-produce anything they think will sell.

Besides painting the Old West, a great many of these artists, often natives of Connecticut or New Jersey, adopt a western life-style and appearance. Some go so far as to wear pointy-toed boots and silver belt buckles, ten-gallon hats and droopy mustaches, bola ties and pounds of turquoise jewelry. In extreme cases the artist becomes such a spectacle that the work seems dull and uninteresting in comparison.

Obviously these artists feel that their costume improves their effectiveness as professional artists. This may be true. Western art is a specialized field and western paintings and sculptures are sold in unique ways—at steak fries, rodeos, and banquets at the Cowboy Hall of Fame. The western costume is appropriate at these functions and in some way it lends an air of authenticity to the artwork.

Other genres of artists affect their own peculiar uniforms—the black artist who won't appear in public without his dashiki; the native American artist who woos his collectors in a ribbon shirt, braids, and a big, black hat; the feminist artist who appears at receptions in work pants, motorcycle boots, and a leather jacket. For these artists the costume, combined with related speech and behavior patterns, provides a visible identification, a concrete signal to the public of their artistic inclination.

Whether this role-playing is ultimately good or bad depends on the individual artist and his or her situation. One of the biggest dangers of adopting such a specific image is that it tends to limit an artist's career. An artist who becomes established as a Western artist may have trouble finding acceptance for any other kind of artwork. Or, an artist who promotes herself as a militant feminist may alienate art collectors who disagree with her political point of view.

Another problem with assuming such a flamboyant role is that people may think of you as something of a clown, and look at your work in the same light. Perhaps the biggest reason to avoid this kind of role-playing is that it takes a great amount of time and energy away from creating art.

How then should an artist appear? The key word is *professional.* Do not try to hide your own personality or style, but dress appropriately for the situation. Always carry yourself with dignity and assurance. Beyond that, strive to project an aura of success.

Many artists have told me that the single, most important impression to convey to the public is success, and I heartily agree. To collectors, dealers, and other artists, your appearance should say, "I am a successful artist." Your clothes, bearing, and words—everything about you—should tell people that you

are doing well. One artist told me that if he had only $100 to spend on promotion, he would use it to buy a good suit.

Only in movies do collectors rush out to buy paintings from down-and-out artists. With very few exceptions, most collectors want to buy work from artists who are on their way up. Even the buyer who doesn't care about art as an investment, who merely wants a pretty picture to hang above the sofa, likes to feel that the picture was painted by an artist who is "going somewhere." Especially when the prices of your paintings and sculpture move up into the thousands, collectors want to know that you are successful. They may appreciate a fine painting by an obscure artist, but rarely will they offer a lot of money for it.

I know artists who wear paint-splattered jeans and threadbare jackets, and talk about how they suffer for their art. Some are good artists and they can't understand why no one wants to buy from them. They don't realize that people want to identify with success, not suffering. People don't want a painting on the wall that constantly reminds them of misery.

Whatever else you do to promote your artwork, start with a very positive personal appearance. You can spend thousands of dollars on newspaper and television ads; you can print cards and brochures, and four-color books about yourself—but if your personal appearance doesn't convey success, it will undermine everything else you do. You cannot overestimate the importance of your own image.

There are unique problems for the woman artist. In America the female body is used to sell everything from automobiles to toothpaste. Should a woman use her body to sell her artwork? I have seen women artists batting their eyelashes and flashing their cleavage at male collectors, with the implicit suggestion that if he buys a painting, he will get the artist as well. It is a very effective sales device, but I think it's a mistake. Women artists have enough trouble convincing the world that they are not hobbyists, housewife artists, or dilettantes, passing the time painting until they find someone rich to marry or have a baby. Seducing one's collectors only makes it harder to establish an image as a serious, professional artist. Moreover, there is the very important consideration that many collectors are women. One sure-

fire way to alienate a female collector is to make her feel that you are threatening her marriage.

Talking about Yourself

Denver is a city of one million people; it is not a small town. An artist might feel relatively anonymous here, but it would be a self-deception. One artist says something to another artist in a supermarket on Monday. By Tuesday half a dozen other artists have heard it. On Friday a number of dealers have heard it, and by Saturday the collectors know. The art community of Denver thrives on gossip and it is no different in other cities and towns. This is a broadcasting system that no artist can afford to ignore. If used well, it can be a tremendously effective means of promotion; if misused, it can do you great harm.

You can't always control what other people say about you, but you can be selective about what you say. The rule again is to project an image of success. One artist told me, you should be as ebullient as possible without being dishonest. Another went even further: go ahead and lie; even if you're broke and no one has looked at your work for months, say that you're doing great.

Artists like to talk to other artists. I have experienced a great temptation to unburden myself with other artists, to voice all the frustrations, anxieties, and petty worries I face in the art business. However, I have found that artists, like most other people, are not discreet. Unless I am talking to a very close friend, I try to say nothing that I wouldn't want broadcast to the community at large.

Outside of the art community, what you say about yourself and your work is also very important. People are interested in artists, they want to meet us, talk with us, and understand who we are and what we do. No matter how boring, fatuous, or repetitious these encounters with the public are, the artist cannot afford to be rude. Every person should be thought of as a possible collector. Even if you know that a person is not a collector, you must assume that he or she has a friend, a cousin, a boss, or a neighbor who is a collector, and the impression you make on this person will undoubtedly be passed on. I cannot

overemphasize the importance of being gracious to anyone who expresses interest in your work.

What you say specifically about yourself and your work is another problem. How do you answer when someone asks, who are you and what do you do?

First of all, never be embarrassed to say, "I am an artist." It is not pompous or pretentious. If you are a professional artist, say, "I am an artist," and say it with confidence. As far as telling people what you do, they rarely want a long, involved explanation. Keep it short and simple—I am a painter or sculptor. I work mostly in oils or pastels or bronze. I paint abstract pieces or I paint realistic landscapes or figures. Try to say one thing about your work that is especially interesting or impressive —I just returned from a painting trip in Africa; last week I was admitted to the American Watercolor Society; yesterday the First National Bank bought one of my bronzes. Then if the person still expresses an interest, offer to send a brochure with reproductions of your work or invite him or her to view your work in your gallery or studio.

Your Studio and Your Image

Some successful artists paint in their kitchens. They don't have studios and they don't see a need for them. However, for most artists a studio is a working necessity, and for those artists the studio can serve a secondary function as well—of enhancing their professional image. Whether you invite people to your studio or only refer to it in conversation, a studio helps establish your credibility as an artist.

The studio can provide an excellent setting for meetings with dealers, art reviewers, or potential buyers. How can anyone doubt that you are a working artist when they see the physical evidence of your labor around them? The studio must look like a place of work. A spotless room with framed paintings on the walls, a new easel in the corner, unused brushes, and unopened tubes of paint on a table will not do. People will be aware that it is really a gallery disguised to look like a studio.

Don't be afraid to show people a studio that isn't the "ideal

studio." It can be a converted bedroom or garage and it need not be absolutely tidy. For most artists an immaculate studio is an unnatural phenomenon, and people expect to see some evidence of your work. Having a newly-primed canvas, some work sketches, or a sculpture mold in sight gives you a great opportunity to discuss some of the processes and techniques that you use. At a cocktail party, people don't want to hear detailed explanations of how you work, but those who come to your studio will usually be interested. Moreover, it gives them the sense that you are somehow including them in your work; it makes them feel personally involved.

Though you don't want your studio to look unused, you also don't want it to look squalid or chaotic. Leading potential buyers through an obstacle course where they are constantly afraid of knocking over a wet painting or a tub of melted wax will not make buyers more enthusiastic about your work.

Business Cards, Calling Cards, and Stationery

I used to think that business cards were of use only to traveling salesmen. When I became a professional artist, I changed my mind. I quickly realized that the business card is a very useful tool, especially for artists.

As an artist, your name is the keystone of your total promotional program. Your name identifies both you and your work. The first and biggest hurdle is to get people to know your name. After you establish your name in people's minds, they will associate it with your work, and perhaps come to a better understanding of your technique and philosophy. But first they must know your name. When I meet Mr. Jones, who is a collector, I say, "Hello, I am Carole Katchen." Mr. Jones hears my name. Then I hand him my card, and he sees my name, Carole Katchen, in print. Mr. Jones is now more likely to remember my name, and besides the immediate impression, he has something tangible to remind him of who I am. The business card is also a convenient way to pass on your address and phone number. Of course, you can write this information on a piece of paper, but generally a printed name is more impressive than a hand-written

one, and it is easier to keep a card than a scrap of paper.

When you design your business card, you should keep its purposes in mind. First of all, you want Mr. Jones to see your name, and so your name should be prominent and readable. Beyond that you want to make it easy for him to contact you. Give him all the pertinent information concerning your whereabouts: a complete address with number, street, city, state, zip code, country (if you have international contacts), and telephone area code and number. If you want to reaffirm your identity as an artist, include a simple identification label, e.g., artist, graphic artist, sculptor.

I have seen artists' business cards that range in design from austere to rococo. The most important advice I can give about design is that the card should look professional. It should be neat and legible, and have professional type—rub-on letters rarely are straight and evenly spaced, and lettering done on a typewriter or by hand looks very non-professional. Also, your card should be printed professionally. Many printers specialize in business cards and their charge for a simple card is a very small investment in establishing your professional image. In addition, your card should be printed on a fairly heavy stock of paper; a card that feels substantial implies that your career is substantial.

The look of your card should be determined by your own taste and budget. Many artists use colored paper and/or ink. The greatest visual contrast is created by black and white; black ink on white paper is also the easiest to read. However, a colored card is much easier for a collector to locate when he or she wants to contact you. Lee Milmon, an artist who works primarily with geometric shapes in neutral colors, printed a business card with a simple geometric design in gray and white. Ramon Kelley invested in a card that shows a very fine reproduction of one of his paintings. These are two ways that artists have used business cards not only to transmit the basic information, but also to convey something about the nature of their work. Jon Zahourek has a very striking signature; he included it, as well as his name in print, in the design of the card. This reinforces remembrance of his name and creates a more visually interesting card. Jean Kent Ullberg printed a card with both his addresses in

Colorado and in Sweden; this immediately informs the reader of Ullberg's international reputation. The possibilities are endless.

One caution regarding reproductions of work on your card: Any reproduction on your card should be *typical* of your *current* work. Both of these elements are important. If you paint traditional landscapes, do not put a whimsical caricature on your card—it will convey the false impression that your most important work is whimsical caricatures. Then, you will find yourself constantly explaining that this is not typical of your paintings. Also, if your work is in a state of transition—perhaps you feel there will be a significant change in your style or subject matter or that your work will improve in the near future—it probably is unwise to invest in a reproduction that shows what your work is like now.

Another basic form of printed material that helps establish your professionalism is personalized stationery. One artist told me that stationery is what represents you when you are not there to represent yourself. Often a piece of writing paper and an envelope are the only tangible evidence that an out-of-state dealer or collector will have of your professionalism. Once again, the professional image should be of primary concern in your stationery design. Keep your printed material neat and legible. It should not be so large or ostentatious that it detracts from your written message. As I mentioned before, if you use reproductions of your work in your letterhead, be sure that they are current and typical. The paper shouldn't be as heavy as a business card, but I believe it should be a fairly substantial weight. And if you use colored paper, be sure that it is not so dark or bright that it makes your message difficult to read.

Neither a card nor personalized stationery is an absolute necessity to the professional artist, but they can be very useful tools.

CHAPTER 2

PUTTING YOURSELF ON PAPER

One of the harsh realities of the professional art world is that the general public is often more concerned with your credentials than with your artwork. Even the better-educated art buyers are more likely to discuss an artist's career than his or her work. If an artist is elected to the American Watercolor Society or receives a grant for international travel, the news goes out on the grapevine immediately. But who ever hears that an artist has achieved a new subtlety in his use of line or a greater strength in her sculptural composition?

Art buyers want credentials. If you can give them credentials, you will have taken a major step toward proving that you are a professional. The most effective way of showing your credentials is a resume that you can hand to buyers, send with press releases to magazines and newspapers, and include in invitations, brochures, and catalogs. Following is a guide for creating your own resume.

What Is a Credential?

Any artist who has been functioning in the professional art world for some years will have acquired some formal credentials. Solo exhibitions in galleries, inclusion in major invitational shows, feature articles in publications—these come naturally with time and persistence. However, for the new professional credentials can seem to be a real problem. I say *seem* because there are many kinds of credentials and I believe that even the newest professional will have enough of them to create a presentable resume or career summary. A resume is usually a for-

mal listing of credentials; a career summary is a paragraph or two that highlights a few major credentials.

When I say that almost anything can be a credential, I am not being facetious. Some years ago I hitchhiked across North Africa. With watercolors and ink, I sketched people in markets and on buses from Morocco to Ethiopia. This was as important a learning experience for me as any university art class I ever took, and as such it has a valid place in my resume.

We tend to think that the only important credentials are the formal, institutional ones: university degrees, major exhibitions, awards, grants, public commissions, inclusion in public or corporate collections. This is not true. In a workshop I gave on promotion, a sculptor showed pictures of some very fine tropical fish pieces he had welded. When asked to state his credentials, he shrugged his shoulders and mumbled, "Well, I really don't have any credentials; I just started doing sculpture a few years ago." As I questioned him about his background, he said that he has been a professional welder for eighteen years and a scuba diver for nearly as long. This sculptor who said he had no credentials had great technical expertise as well as a firsthand knowledge of undersea life. His resume should reflect these skills.

Being a parent is a credential for someone who paints children. Hiking and camping in the wilderness are credentials for landscape and wildlife artists. Living in a slum is a credential for a painter of social realism.

The kind of art you do generally reflects the kind of life you live. So look at all the aspects of your own background to determine what credentials you have. Any activity or experience that has had a real effect on your artwork is a credential.

How to Write a Resume

I believe that all professional artists should compile a complete, detailed resume—a listing of the "vital statistics" of their life and career. Once you have all of this information on paper, it is relatively easy to sift through and choose those elements that will most interest and impress the art buying public.

A resume, either a full or selective resume, is useful in applying for grants or awards, in presenting oneself to a new art dealer, or in seeking publicity from an art magazine. A career summary, which is shorter, is good for inclusion in invitations, brochures, and press releases.

The best way to start a resume is to make a list of everything that might have a bearing on your work. Begin with basic personal data: birth date and place, marital status, children, where you live and have lived, general work experience. Then list your formal art credentials: education, exhibitions, gallery affiliations, grants and awards, sales to major collections, membership in professional organizations. Finally, list your personal credentials: special interests, hobbies, travel or other unusual or interesting experiences, and persons who have influenced your work.

The next step is to bring some order to this mass of information. Decide on the categories of information that you want to include in your resume. The topics in my resume are Personal Data, Education, Art Career, General Work Experience, and International Travel. Obviously every art career is different; so every resume will be different. Choose general topics that are most applicable to your own career.

Then divide the information on your initial list into these categories, arranging items chronologically. At this point you should eliminate duplicate listings and items that are irrelevant to your art career.

As an example of a beginning art professional, suppose a middle-aged woman artist is now ready to commit herself to a professional art career. This woman wanted to be an artist before she was married, but because of her commitments to her home and family waited until now to pursue this ambition. She has continued to paint since her youth and her paintings, mostly still lifes of plants and flowers, are quite competent; she feels insecure, though, because she lacks formal credentials. Included here is her general resume and from that we will create a professional career summary.

Margaret Hastings Burns

Born May 10, 1933, Denver, Colorado

Married November 25, 1953, to Paul Burns, engineer

Children -- Sharon, born 1955

James, born 1957

Steven, born 1958

Education

Studied 2½ years at University of Colorado, Boulder,

Art Education, 1951-3

Art Career

Won award in city art contest at age 14, 1947

Showed paintings in student art show, University of Colorado, 1953

Took adult education classes in painting, drawing, and design

at Washington Park Community Center and Community

College of Denver

Attended watercolor workshops with Charles Reid and

Chen Chi at Foothills Art Center, Golden, Colorado

Exhibited paintings in several sidewalk and shopping center shows

Won second place in painting at Lakeside Shopping Center

Spring Art Show, 1976

Interests

Has studied mountain flowers since youth; led several Girl

Scout trips to study mountain flowers; taught three

classes on wildflowers of Colorado at YWCA

Is a dedicated gardener; has won several awards for roses

From Margaret Burns' resume we see that her "formal" cre
dentials are an art award in high school, one college art exhibit,
several sidewalk and shopping center exhibits including one sec-
ond prize, and several workshops and adult education classes.
These have all been significant experiences for Margaret—all
valuable for increasing her skills and confidence. As *profes-
sional credentials,* however, they lack substance. She might be
able to use them in a general way, but if she lists them specifi-
cally, they will do her more harm than good. To dealers and
serious art buyers, listing high school awards and sidewalk
shows indicates that you don't have any weightier credentials
and they may feel that you aren't an artist to be taken seriously.

What I see as the most significant feature of Margaret's art
background is that she has been painting and studying art consis-
tently since 1947. She has been painting for approximately thirty
years, and this, I feel, is a very impressive credential.

Another important element in her background is her interest in
flowers. She is a dedicated gardener who has won awards for her
own flowers. Moreover, she is an expert on the wildflowers of
Colorado. These facts are significant because she paints plants
and flowers.

Using just these two features, Margaret Burns can put to-
gether a very presentable career summary:

Margaret Burns, Colorado native, is a painter with thirty
years of art experience. She received her first art award in
1947, and she has continued to paint and study art since
then. Her still life paintings of plants and flowers have their
foundation in her lifelong dedication to botany. She is an
award-winning gardener and a recognized expert on Colo-
rado wildflowers.

Following are examples of two actual resumes:

Jean Kent Ullberg

Born in Gotenburg, Sweden, 1945

Studied at the Swedish State School of Art, and Swedish

 Museum of Natural History in Stockholm.

Worked and studied at museums in Germany, Holland, and France.

Lived in Botswana, Africa, for seven years, spending countless

 hours observing, sketching, and photographing wildlife.

Served the last four years in Africa as a curator at the

 Botswana National Museum and Art Gallery.

Recently served as a consultant and manager for the African

 exhibits project at the Denver Museum of Natural History.

Works have been shown in numerous galleries and museums in

 Europe, Africa, and U.S.A.

Selected for Allied Artists 61st and 62nd Annual shows in

 New York and the National Academy of Design, N.Y.,

 awarded The Barnett Prize in the 150th annual show, 1975.

Invited to show in Colorado Celebration of the Arts, 1975

 and 1976 exhibitions. Given award of merit 1975.

Exhibited at the International Game Conservation Conference

 in San Antonio, Texas.

Commissioned by Colorado Governor to execute bronze award 1976.

Listed in Who's Who in American Art.

Doug Dawson

		
1973	American Watercolor Society Show Selected for Matted Traveling Exhibition	New York, N.Y.
1974	American Watercolor Society Show Selected for Framed Traveling Exhibition Emily Goldsmith Award	New York, N.Y.
1974	Rocky Mountain National Watermedia Exhibition Paschal Quackenbush Award	Golden, Colo.
1975	Film: "The Mind of the Artist" (Documentary on Dawson and his work) Producer: Arch Bryant (Cine Support) San Francisco International Film Festival Rochester International Film Festival (award)	Denver, Colo.
1975	Pastel Society of America Show, Bainbridge Award, Member	New York, N.Y.
1975	Published: "The Canvas Connection" (article on art investment), Denver 12/75	Denver, Colo.
1976	American Watercolor Society Show	New York, N.Y.
1976	Published: "Commercial Reproductions -- "The Great Art Rip Off!" Colorado Woman Digest, 6/76	Denver, Colo.
1976	American Artist Magazine 8/76 (article on Dawson)	New York, N.Y.
1976	Pastel Society of America Show	New York, N.Y.
1977	Salmagundi Club Member	New York, N.Y.
1977	"The Colorado Exhibition," Arvada Art Center	Arvada, Colo.
1977	American Watercolor Society Show; Member	New York, N.Y.

In most cases a brief career summary is preferable to a lengthy recounting of specific credentials. Especially in an invitation or brochure, where the printing costs increase with the amount of type, you will want to keep your material short and simple. Generally, people are not interested in reading more than a short paragraph and they are more likely to remember what they have read if you include only the most interesting and impressive aspects of your career.

The following are some career statements taken from *The Timeless West,* an exhibition catalog prepared by De Colores Gallery of Denver in January, 1977.

A native of Lubbock, Texas, Glenna Goodacre received her B.A. degree from Colorado College, and studied at the Art Students League in New York. Her oils and bronzes of the Southwest have received numerous major awards, and her bronze portrait commissions include such noted figures as John Wayne and Dan "Hoss Cartwright" Blocker. Most recently, her work has been exhibited at the National Academy, the Cowboy Hall of Fame, and is featured in *Southwest Art,* December, 1976.

Gene Hamby's Cherokee and Chickasaw heritage and his lifelong interest in woodcarving provide the impetus for his creation of intricately rendered Kachinas. He uses a variety of materials including leather, feathers, and bells to fashion works that are not only unique artistic statements but also historically accurate. Gene is presently head of space planning and interior design with the architectural firm of Seracuse, Lawler & Partners.

Ray Knaub is noted for his paintings of western subjects in several media. His work has been represented in numerous regional and national exhibitions. Ray was born in Nebraska and received his BFA from the University of Nebraska. He is art instructor at Green Mountain High School and a past instructor of art at Community College of Denver, Red Rocks Campus. Knaub is listed in *Who's Who in American Art,* 1976.

One important caution: when writing a career summary *avoid
excessive use of cliches and adjectives.* Keep your statements as
simple and direct as possible. You are not trying to win literary
awards; you are trying to impress people with your professional-
ism as an artist. Here are some statements from catalogs and
invitations that are so obscure and general that they are nearly
meaningless. Say what you have to say so that the reader can
easily understand and remember it. The purpose of your resume
is to communicate information.

> His daring conceptions reflect the mysticism and poetic
> tradition of his Italian heritage, and his pride and ardor are
> reflected in his work.

> Noted for an incisive mastery of design and color, her fig-
> ure paintings and evocative nature studies bring a new di-
> mension of feeling to esthetic art.

> Only the essential elements are rendered with a frugal but
> vivid palette to communicate the special ambience that is
> the rural Southwest.

These statements sound very impressive, but without rereading
them, can you remember what they said?

Building Your Credentials

As you plan your art career, it is good to keep in mind the
pursuits that will add to your resume. The beginning profes-
sional can benefit from any exhibition. Shows held in churches,
restaurants, community centers, especially if they are one-artist
exhibits, are invaluable in teaching you how to present yourself
and your work to the public. However, most of these beginning
shows do not enhance your resume. So it is beneficial to start
working early toward exhibitions in galleries and public institu-
tions, especially museums and university galleries. Generally
the well-established commercial galleries are unresponsive to
beginning artists; so try the new galleries in your area. The gal-
lery business is a precarious one—galleries open and fold regu-

larly. Keep aware of new galleries. They need artists and they will be more receptive to your requests for exhibition space.

Bob Ragland, an artist who has a very impressive resume, says he watches out for empty walls wherever he goes. One afternoon when he was visiting Colorado Lt. Governor George Brown, Bob noticed that the office walls were bare. He asked if the lieutenant governor would be willing to show work by Colorado artists in his office. The politician was delighted with the idea and out of that grew the Art in the Capitol Program, an excellent credential for Bob Ragland, its coordinator, and for the many artists who have now exhibited their work in the Colorado State Capitol.

As for most museum and university shows, until you have established a major reputation for yourself, these exhibits depend on the personal connections you have with the institution.

Many artists recommend entering national competitive shows to build credentials. Some of the major competitions include Allied Artists of America, National Academy of Design, Pastel Society of America, and American Watercolor Society. To obtain information about these competitions and other kinds of awards, grants, and public commissions, you should read art magazines and local and national newspapers; *American Artist*, for example, carries a monthly column on competitions. Many museums and universities also sponsor contests. For information on these, you generally have to contact the institution directly.

The main disadvantage of these shows is that they are expensive to enter. You usually have to pay an entry fee and shipping costs, and your work may be lost or damaged in shipping. Moreover, the judges may reject your work. For many of the national shows, the percentage of accepted entries is very, very small. However, acceptance to a national competition is a solid credential, and winning an award in one of these shows is even more impressive. Another advantage of national competition shows is that they can lead to membership in major national organizations, e.g., National Academy of Design or American Watercolor Society. These are excellent credentials. The only way to become a member of some of these groups is through accept-

ance in their annual competitions. Contact the various organizations for more specific information.

Generally, membership in a local art club or guild is not a strong credential. Regardless of the nature of the particular group, listing such an organization as a credential tends to make people feel that your career is local rather than national in scope.

Travel and study add to your credentials. Recently I spent a few months in London, where I took classes at Morley College and the Camden Art Center. No matter how successful your art career is, study at a major institution will enhance your credentials. Many people also feel that study with an important artist adds to their credentials. The danger of listing study with another artist is that it can cast doubts on the originality of your own work.

You do not have to study at a formal institution to use travel as a credential. An artist who does wildlife sculpture told me that traveling in Kenya added validity to his work in the eyes of many of his collectors.

It is not terribly hard to arrange exhibitions of your work abroad. Many American embassies and offices of the United States Information Agency hang regular art exhibits. If you are planning to be in another country for some time, contact those agencies for possible exhibitions.

Finally, selling your work is not usually a credential, but if you sell a piece to a major public or corporate collection, or if a major collection accepts the donation of a piece of your work, you can add that to your resume.

There are countless sources of credentials. If you continue to work as a professional artist, you will eventually find that you are amassing credentials without even thinking about it. In the beginning, though, do think about it. Be aware of how all of your professional activities will look on your resume and never miss an opportunity to add a credential.

How to Rewrite Your Resume

As you acquire more credentials, add them to your general resume. Refer back to that comprehensive resume whenever you

have to write a current career summary. Always include only your most important credentials in a resume for the public. Important awards, specifically stated, are usually more impressive than general summaries. So as you acquire these credentials, add them to your resume and eliminate the less important ones.

Statements of Personal Philosophy

Besides the solid facts of your art career it is good to put on paper some of your thinking about why you are an artist. Throughout your career people will ask why you became an artist and why you do the kind of work you do. By analyzing your own philosophy and actually writing it down, you will be better able to deal with those kinds of questions. Two rules for writing a statement of philosophy are: (1) keep it short, and (2) keep it honest. Remember that the purpose of the statement is to help people understand more about who you are. Here are some excerpts from other artists' statements:

"I paint people because I have very strong feelings about the isolation that is part of being a person."—Doug Dawson

"I am a young woman living in 1975 and I reflect my life today and the times I live in."—Lee Milmon

"I try hard not to be a reactionary artist. In the end I can't resist it."—Bryan Waldrip

"I would like my work to be statements. I would like the viewer to be extensions of those statements."—Bob Ragland

A statement of philosophy tells something about your beliefs and aspirations, your commitment to art as a means of expression and communication. It helps people understand why you have devoted your creative life to art. It shows people that you are a serious artist whose work is more than a means of making money.

The biggest danger with a statement of philosophy is that it is very easy to sound pompous or insincere. Be direct, simple and honest in what you write about your work. Marsha Melnick, of Watson-Guptill Publications, adds this note about statements of philosophy: "It has been our experience working with dealers and critics that there is some sort of resistance to a philosophical

statement of this nature. It seems to me that an artist's work somehow manages to convey his or her philosophical position much more effectively and dramatically than his or her words on the subject.''

Photographs of Yourself

I cannot overemphasize the importance of photographs in promoting an artist's career. I always keep a stack of professional, high-quality photos of myself available; they are one of my most valuable promotional tools. They are 8″ × 10″ (20.3 cm × 25.4 cm), black-and-white prints of me in various surroundings—painting in South America, hitchhiking in Africa, being interviewed in a television studio, posing in front of exhibits of my work. One good photograph can go a long way toward establishing your image as an important, working artist. People who may ignore printed material may be inclined to stop and look at a striking photograph.

If you cannot afford a professional photographer or if there isn't one available, have your friends or relatives, or even strangers on the street, snap your picture. If you take enough photos, there are bound to be some that are good enough to enlarge to 8″ × 10″ (20.3 cm × 25.4 cm) to use for publicity. The best ones are pictures of you in unusual places doing interesting things related to your art career. They should be black-and-white pictures that show clearly who you are and what you are doing.

The amount of space and attention you get in newspapers, magazines, invitations, and catalogs will increase tremendously if you include eye-catching photographs of yourself.

Omitting the Truth, Distorting the Truth, and Lying

With your resume, statement of philosophy, and photos, you have a solid presentation of yourself as a professional artist. But is that artist really you?

Is it possible to compile completely truthful facts and statements but create a total lie? Yes, absolutely. The way you state the truth or part of the truth can create any number of impres-

sions. You must decide which is the most honest for you.

One of the problems I face in writing my own career summary is that I am not a prize-winning artist. In addition, my work is rarely even accepted for competitive shows. Meanwhile, the artists around me are stacking up awards like hot cakes. I received one college art award; so I could write about myself as Carole Katchen, prize-winning artist. While this statement is true it is certainly misleading. Therefore, I have decided that it is better for me to emphasize my strengths rather than emphasize my awards.

Another impression I try not to give is that I am an artist with a strong academic background. I have a university degree, but it is not in art. I have taken numerous art classes from numerous institutions, but it's been a piecemeal affair, certainly not the equivalent of a four-year Bachelor of Fine Arts program. My major art training came from working as a commercial artist and art editor for ten years before I decided to be a gallery artist. So in my resume I mention my art studies, but I usually lump them together with my painting trips—e.g., Carole Katchen has studied and painted in many parts of the world.

I am an artist who is most concerned about painting and about exhibiting my paintings. In my career summary, I emphasize my subject matter, since I consider it the most important aspect of my work—e.g., she generally paints people active in their daily lives; her subjects have included Colombian Indians in markets, Ethiopian natives on buses, and dancers and musicians in rehearsal with the Denver Symphony Orchestra. Also I stress the exhibitions of my work—she has exhibited her work widely in the United States and South America. I want my resume to say who I am. I see no value in trying to represent myself as someone else.

CHAPTER 3

PRESENTING YOUR WORK

The basic reason for promoting yourself is to encourage people to see your artwork. If you promote yourself effectively and positively, they will not only want to see the work, but they will want to like it. This is why the kind of image you convey is so important. If you make people think the artist is interesting, they will also think the artist's work must be interesting. And if people find the artist impressive, they will probably find the work impressive. How they respond to you as an artist and a person will have a great effect on their attitude when they view your work.

You should present yourself and your work as professional. Viewers should respect your work before they ever see it.

Describing Your Work

How can you describe in words a visual work of art? Many artists simply refuse to deal with this problem. They say: I can't describe my work; you have to see it. This is a simpler path for the artist to take, but it severely limits communication with the potential viewer.

Many art viewers, and especially serious collectors, want to know something about an art exhibit that they are going out of their way to see. They don't want to waste their time on works that won't interest them. So if you refuse to tell them anything about your work, you are losing possible collectors. This is true of dealers and critics as well; you have to give them some description of your work in order to interest them in it.

In your printed promotional material as well as in personal

contacts, it is valuable to give people some concept or image of what it is you do. My suggestions for describing yourself as an artist are the same ones I suggest for describing your artwork: keep it simple, brief, honest, and interesting. Tell people just enough so that they have some idea of what you do and will be interested in seeing your work, but don't tell them so much that you bore them. Not everyone is going to relate to your work; your descriptive statement should help you reach those who will.

There are many ways to describe artwork. You can talk about technique, subject, or mood. You can analyze one piece or discuss the total body of work. The main things to ask yourself are (1) does this say what the work is like? and (2) will this interest a prospective viewer?

Generally non-artists aren't interested in discussions of technique. Unless you are using a very unusual medium, it is best to avoid technical descriptions. A brief indication of medium and style—large abstract bronzes, small representational watercolors—will usually tell the viewer all he or she wants to know about the technique before seeing the work.

What Motivates You?

Usually the most exciting facet of a piece of work is the reason why you chose that particular subject. Why did you paint that farmhouse? Why did you model that gazelle? With non-objective work as well, the reason why is usually more interesting than the style or technique. When you describe a piece of work, think of what you wanted to express when you began the piece. What attracted you to the subject? This is usually what your viewer wants to know.

For instance, in 1976 I painted a large number of still lifes. When trying to give an interesting description of these pieces for promotional material, I ran into tremendous problems. They are simple, realistic paintings of flowers and fruit in bowls or on tables, nothing that sounds very exciting or unique. Then I thought about why I started doing still lifes in the first place. I had been living in London during a gray and unusually cold

winter, and missing the Colorado sunshine, I bought some daf-
fodils to put in my room. These flowers became my best friends
in London, a link with home. I studied their colors and shapes
and I started to paint portraits of them. Since returning to Colo-
rado, I am still attracted to flowers and fruits with bright, warm
colors and I paint them not as impersonal still lifes, but as por-
traits of friends.

If a piece of work was done under unusual circumstances, that
can also provide material for an interesting description. In 1973 I
decided I would like to draw symphony musicians. I contacted
the Denver Symphony Orchestra and obtained permission to
attend several rehearsals. I wanted to draw musicians who were
actively involved in the process of making music. So I took my
ink, pastels, and watercolors up onto the stage of the Civic
Auditorium and, sitting on the floor between the basses and the
violas, I drew musicians.

When you describe your paintings or sculpture, think about
what makes them special. Look at each piece carefully. If you
have seen it so much that you can't see it now with a fresh eye,
look at it in a mirror. Invite a friend to look at the work with you
and describe to that person what makes the piece unusual.
Sometimes talking about your work to a friend is easier than
writing about it. Once you find the right words in conversation,
you'll probably find it easier to put them down on paper.

Always write about the best aspects of your work. Never
apologize for the flaws. Every painting or sculpture has weak-
nesses. What makes a work salable is its strengths. Talk about
the strengths of your own work; don't draw attention to the
weaknesses.

Here are some examples of clear, concise descriptions of
work:

His work ranges from traditional to modern, with dramatic
landscapes characterized by vivid color and powerful
compositions.

He devotes himself to capturing the life spirit of the Indian
people of the past by using bold, visible brushstrokes and
large negative areas. Because his palette is primarily

earthen or muted, periodic flashes of color surprise and delight the observer.

In his portrayals of this model, clothed or nude, there is always a strong emphasis on the face and the emotions the artist finds there.

When I listed the qualities of a good description, I included honesty. This is not merely an ethical consideration. There are some very practical reasons for describing your work accurately. When people come to see your work, they will have definite expectations based on your descriptions. If their expectations are unrealistic, they will blame you. They may feel that you and your work are pompous, arrogant, even ridiculous. Once you have created this impression, it is very difficult to amend. Be positive about your work and talk only about the strong points, but do not exaggerate or distort the truth.

The biggest fault I find with most artists' descriptions of their work is a tendency to generalize. Be specific in your description. What *specifically* makes one painting different from any other? Here is one example of a description that is too general:

The human subject, landscape, and still life are described in rich but subtle color orchestrations with spontaneous brushwork that reflects the artist's complete mastery of his craft and his triumph over contemporary fads and dull academic picture-making.

This really doesn't give any specific idea of what the artist does. "Rich but subtle color orchestrations" has a terrific ring to it, but what does it mean? "Contemporary fads" and "academic picture-making" could mean many things.

Another common problem illustrated by this example is overstatement. Does any artist ever achieve "complete mastery of his craft?" Here is another example of blatant exaggeration:

"Awe-inspiring" is an understatement of his magnificent presentations of the grandeur and drama of the American West.

Superlatives of any kind should be used sparingly. Brilliant,

superb, exceptional, stunning, breathtaking—these should only be used if you can substantiate them with specific facts or details. Here is an example of a successful use of a superlative:

His exceptional ability to capture the mood of the Rocky Mountains stems from his experience as one of the area's better mountain climbers.

One reason not to overstate or exaggerate is that people are likely to feel let down if the work doesn't live up to the description. Another reason is that one untrue statement makes the reader doubt the honesty of the total description and the sincerity of the work itself.

There is also a temptation to try and impress the reader by using long, complicated sentences. The usual result of these descriptions is to leave the potential viewer slightly dazed and very confused. Sometimes just dividing a very long sentence into shorter sentences will make the statement stronger and more understandable. For example:

The sculpture is realistic in form and detail, and yet, there is an impressionistic aura surrounding the piece, a looseness which adds a sensitive dimension as well as the flowing, dynamic quality of unrestricted freedom of motion in the leap.

This becomes:

The sculpture is realistic in form and detail, and yet, there is an impressionistic aura surrounding the piece. A looseness adds a sensitive dimension. The leap shows the flowing dynamic quality of unrestricted freedom of motion.

This may seem less poetic, but it is really just more understandable.

There are times when a more poetic statement is effective, especially in cases where the most important aspect of the work is the mood.

His paintings invite you to enjoy the quiet moments of rest so well deserved, the companionship of old friends where no words need be spoken and memories sing.

A very important aspect of promotion is research. You should read everything that relates to what you are doing. If you are writing descriptions of your work, read other artists' descriptions. Read invitations, brochures, and reviews to see how other artists have handled the same problems. Notice how their writing succeeds and how it fails. This will help greatly when you write your own description. However, do not copy another artist's statement. It is very unlikely that a description of someone else's work will effectively describe your own. Also, if people notice that you copied another artist's promotion, they might also think you copied his or her work.

Again let me state that in writing a description you should begin with your own work. Look at your work; study it. Then pick out the most important elements and state them simply and directly. Avoid generalization and exaggeration. Avoid cliches, the descriptive expressions that are used over and over— "lyrical landscapes," "sensitive character studies." Create a professional image for your artwork that will make viewers respect the work before they see it.

Getting Someone Else to Write about Your Work

Many brochures and catalogs contain descriptions of artwork written by someone other than the artist. Sometimes these are quotations from newspaper or magazine reviews, but usually they are written especially for promotional purposes.

It is possible to hire a professional copywriter to compose a description for you. However, unless the person is a very good writer who knows a lot about art and also understands your specific needs, you will probably do a lot better writing your own material.

Another type of description is the endorsement of your work written by an authority in the art world. In most cases the artist approaches an acquaintance who is an authority in the art world and who likes the artist's work. The artist explains that he or she is putting together a brochure and would like to include a descriptive quotation. Usually the person is willing to write a brief statement.

It is important that the person really is an authority in the art world—an art critic for a newspaper, an editor of an art magazine, a professor of art, a recognized art historian, an art museum director, or a nationally known art collector. You will want to use the title as well as the name. Second, you should know this authority personally or you should have a formal introduction; many people are suspicious of strangers asking favors. Third, the person should like your work; you do not want a strong, authoritative statement of how awful your work is.

What if someone agrees to write an endorsement for you, but only if you pay a fee? Should you pay? If so, how much?

Some key questions of art promotion are how much should you pay and what should you pay for?. Each case should be judged on an individual basis. You must decide if the endorsement is important enough to your career to justify paying for it, and you must decide how much you can afford to spend. If you are publishing an invitation, for instance, you will have numerous expenses already—typesetting, paper, photographic plates, etc. Unless you have unlimited funds, you will only be able to pay for the most important things. You will have to determine what those are.

A description of your work by an authority should have the same basic features as any description you would write; i.e., it should be simple, brief, honest, and interesting. It can be more enthusiastic than a statement you would write yourself or than an unsigned statement: if you say that your work is brilliant, it is pompous; if an authority says your work is brilliant, it carries the weight of his or her status.

If an authority writes a statement for you and it is boring or meaningless, *do not rewrite it.* If you are printing this as a quotation, it must be the exact words of the person quoted. It might be possible to use only part of the statement—if cutting it does not change the meaning or tone. However, if the statement is just plain awful, it is better not to use it at all than to risk the consequences of misquoting an authority in print.

An endorsement by an authority can be useful, but it is by no means necessary. As long as you have a strong description of

your work, written by yourself or someone else, it is not worth a lot of time and effort to pursue an endorsement.

Photographing Your Work

Like photographs of yourself, photos of your work are very important. You need pictures of your work to include in press releases, slides to submit to competitive shows, and photos to show art dealers. Since these pictures represent your work, often to people who have never seen it, high-quality photos are imperative. I recommend using professional photographers for this, and particularly those who specialize in photographing artwork. Small snapshots do not create a professional image and they are likely to be lost or overlooked by art editors and dealers. Be sure each photograph of your artwork has these qualities:

1. It is in sharp focus; it is not blurred or fuzzy.

2. It shows the entire composition. Only on rare occasions will you want a picture that shows a part or detail of your work.

3. The color is accurate.

4. In black-and-white prints the contrast is strong; it is best if the values range from pure black to pure white.

5. There are no glare spots from wet paint or photo lights.

6. There are no shadows on the artwork caused by the frame or the photographer. Photos of sculpture should use the shadows caused by the piece itself to show the form of the sculpture.

7. The background is simple and does not detract from the work. A plain white or solid-color wall is generally the best background.

8. The artwork is square with the camera; the edges of the painting are parallel with the edges of the photo. If the painting is slanted it will be distorted in the picture.

There are special problems in reproducing artwork in black and white. When choosing pieces to photograph, make sure you pick ones with a wide range of values. Middle gray values tend to get lost or blur together. Also, select pieces that will still be interesting if much of the detail is lost in reproduction. Newspaper reproductions are especially poor and tend to lose details and middle values.

With color transparencies that are going to be used for publication, attach a color card to the artwork before photographing. You can buy a color card at most large photo stores. This gives the printer a guide to how much color distortion there is in the photograph.

I keep a photographic record of all the work I frame and show. I have 4″ × 5″ (10.2 cm × 13 cm) transparencies for color reproduction, 35 mm slides, and/or 8″ × 10″ (20.3 cm × 25.4 cm) black-and-white prints. Besides being useful for promotional purposes, they are also useful for insurance purposes. In addition, it helps me remember pieces that are no longer in the studio.

The Physical Presentation of Your Work

If you have promoted your work well, your viewers will come to your art expecting professional-quality work. The physical appearance of the work should substantiate that impression. I am not only talking about the competence of the painting or sculpture itself, but also the finish of the piece—the signature, mat, frame, patina, sculpture base.

Signing Your Work

Of course, your signature is a very personal thing, but it should be consistent with the style of the work. For example, if you paint delicate watercolors, a large, heavy signature can destroy the balance of a painting. It is generally better to avoid large signatures; they tend to detract from the work itself. Also, I prefer a full signature or last name rather than a first name. Signing work with just your first name or nickname creates the

impression that you are not serious about your work, that you are a hobbyist rather than a professional. If your signature looks clumsy, practice painting or carving it until it looks easy and unstudied.

Matting and Framing Your Work

The style of mats and frames you select generally reflects your personal taste. Here again, there should be a consistency with your artwork. For simple graphics I use a simple molding that won't detract from the work itself; for paintings I use a slightly more elaborate frame. I mat all of my prints and drawings with 100% rag board to protect the paper. I consistently use a cream color for my mats; I find that pure white is so brilliant that it competes with my work. Many artists use double or colored mats. I think these detract from the work. Your mat and frame should never be so elaborate that they draw the eye away from the work itself; their purpose is to enhance the work, not to detract from it.

Similarly, sculpture bases should be consistent with the piece. In size, design, and material they should fit comfortably with the piece, being strong enough to support it, but never more impressive than the work itself.

Mats should be cut evenly, and frames should be neatly assembled and strong. Your sculpture bases should be well-polished. Shoddily finished work gives the impression that the work is inferior. The finishing need not be expensive, but it should look professional. Proper finishing of your work shows that you have respect for it.

CHAPTER 4

PUTTING IT TOGETHER— BROCHURES AND PORTFOLIOS

Other than a circus wagon filled with your paintings, the most portable and eye-catching presentation of yourself and your work is a brochure or portfolio. Both the brochure and the portfolio contain at least one example of your work, a statement about the work, some information about you, and possibly a photo. The brochure is commercially printed, and, therefore, is expensive to produce. Because of the cost, it is generally brief. The portfolio is more extensive. It is a collection of photographs, clippings, and typed material, usually in a loose-leaf binder. Both of these can easily be carried or mailed to prospective art dealers or collectors.

Publishing a Brochure

Probably the most common piece of promotion that artists produce is the brochure. It is the simplest professional way of introducing yourself and your work. Brochures range from extensive catalogs of the artist's work to simple one-page statements. The size of the brochure is determined by taste and budget. One important rule to follow is that a beautifully produced one-page brochure creates a better impression than a whole book on cheap paper with poor reproductions.

No matter how big or small your brochure is, it should contain these basic things:

1. Include at least one example of your work. If limited to one reproduction, choose a piece that is typical of your current work that will reproduce well (refer back to the information on photographs of artwork in Chapter 3).

2. Your brochure should contain some description of your work, but it should not be too long, since you are including a reproduction.

3. Include a short resume or career summary; some artists include a list of major credentials. I prefer a more personal statement that indicates why the artist paints that particular subject or in that particular medium, as well as some credentials.

4. A photo of the artist can be included. Though not essential, an interesting picture of the artist can influence the reader's interest in the artwork.

The design of the brochure should be as simple as possible; it will be interesting because of what it contains. If your brochure design is too complex or elaborate, readers will be more interested in the brochure than in you and your work.

One of the most common brochures is a sheet of paper folded in half. The paper may vary in size or shape so that your brochure is either large or small, square or rectangular. It can fold horizontally or vertically. Personally, I feel that any brochure smaller than 5" × 7" (13 cm × 18 cm) is a waste of money. Also, your pictures will be hard to see in a small brochure, there's too little room for type, and the brochure can be easily ignored or misplaced. In designing your brochure leave big margins and empty spaces; a crowded brochure looks cheap and awkward.

Use a good, heavy paper, professional typesetting, and high-quality photo reproductions. You want your brochure to tell people that you are successful. The general look and feel of the brochure makes as strong an impression as the content.

Full-color reproductions are very expensive and they rarely show the work accurately; it is usually more practical to use black and white. Black ink on white paper creates a strong, effective brochure, with or without color pictures. Glossy paper works best for reproductions. I dislike colored paper and col-

ored ink in brochures; they detract from the quality of the reproductions and make the text harder to read.

Look at other artists' brochures before you plan your own. Most galleries have several examples of brochures that you can study.

Dealing with Printers

Being a professional artist means that you have to conduct business dealings. You continually negotiate with galleries, collectors, press representatives, art suppliers, foundries. It is essential for you to fight for your own best interests in every negotiation. No one is more involved in your career than you; therefore you should have even more incentive to represent yourself well. If you have never conducted business dealings before, you may find them awkward or frightening. This is natural. A business negotiation is a battle—you are fighting for your interests; your opponent is fighting for his or hers. As you become more experienced, you will find that it is easier to demand and receive what is important to your career.

Let us take an example of how you negotiate the printing costs of a brochure.

Before you even make an appointment to discuss your brochure with a printer, you must *know exactly what you want.* This is essential to any successful negotiation. Do your research before you call or go to the printer. Look at many brochures. When you find one similar to what you want—in design, size, and weight of paper—get a copy of that brochure to take with you. Next draw a "dummy," a simple sketch of what your brochure will be like. To make a dummy, use paper the same size as your brochure and indicate on it where the text and photographs will go. Neatly type the text you plan to use on a separate piece of paper and take along the photographs. Also decide how many copies you want.

When you have all of this material together, you are ready to talk with a printer. Get the names of some printers from friends or choose those nearest you in location. Here's a little scenario of your conversation with a printer. It might go something like

this: You begin with Mrs. Jones at Jones Printers. You tell her you want a brochure printed and you would like to see some samples of brochures they have printed. Always insist on seeing samples of the printer's work. If it is shoddy, don't waste your time there. Go to another printer.

Tell her you want 500 copies of a brochure printed that is the same size and weight as the sample you have brought with you, $8^{1}/_{2}$" × $5^{1}/_{2}$" (22 cm × 14 cm) glossy paper with two reproductions, one in full color. Show her your dummy, text, and photographs. Explain why you must have a high-quality brochure. As an artist you are especially concerned about the reproductions: they must show your work well. Next you can ask her how much this will cost.

Mrs. Jones will calculate the cost of the paper, the typesetting, the photographic plates, and the printing. Insist on exact prices and *write everything down*. This will help avoid any confusion later, since you'll want an estimate from another printer.

She adds everything up and says, "That will be $500."

You check your own figures and say, "$500. That's a lot of money. Is there any way you can do it for less?"

She scratches her head. "Well," she says, "we could use a lighter weight paper. It will look exactly the same and it will save you $50."

You say, "No, I want the heavier paper. The weight of the brochure is very important."

She sighs. "We could use cheaper photographic plates. It wouldn't make very much difference and it would save you about $30."

You shake your head. "No, the pictures are the most important part of the brochure. They have to be the best."

She smiles. "Well, how about making the brochure a little smaller?"

You shake your head again.

She shrugs. "Usually I wouldn't do this," she says, "but since you're an artist, I'll take $20 off."

"You'll give me exactly the same brochure for $480?" you ask and write the new figure down.

She nods.

"That's very kind of you," you say, "but I'm going to have to check with some other printers before I decide. You know how many expenses artists have. Thank you very much for your time. I'll call and tell you what I decide."

Then you start all over again with the next printer, Mr. Billings at Eagle Press. You say exactly what you want and write down all of his figures. His total is $490.

"Well, Mr. Billings," you say, "Mrs. Jones said she could do it for $480."

"$480?" he asks and looks at his figures. "I could go as low as $470, but that's it."

After you have talked with three or four printers, call the first one back: "Mrs. Jones, this is Margaret Smith, the artist who talked with you about a brochure last Monday. You said you could print 500 copies for $480. I would like to have you do the work, but Mr. Thompson at Star Printers said he could do the same thing for $450. I really can't afford to pay the higher price."

Mrs. Jones answers, "$450? Well, I suppose I could do it for that."

Then you say, "I don't know how I can tell him I'm giving you the job at the same price. Do you think you could throw in an extra 50 copies of the brochure?"

Don't worry about cheating the printer of his or her profit. You are not; no printer will agree to a price that is unprofitable. When you have agreed on a final price with a printer, you still have not finished the deal. Insist on a schedule for when the work will be completed, and ask for it in writing. If it is essential that you have the work by a particular date—if you need the brochures for a specific exhibit, for instance—you can insist that the printers sign an agreement forfeiting part of the payment if they do not meet the deadline. It might also be a good idea to leave yourself and the printer enough time in case the press breaks down. Often the printer will insist on partial payment in advance. Never pay more than 50% until you receive and inspect the brochures. Paying no more than half insures that you will receive your work and that you will probably receive it on time. Also it gives you more leverage for demanding that the

work be redone if it is not acceptable. Check the printer's bill against your own figures. There should be no reason to pay more than you agreed.

Do not accept the work if it is not what was promised. If the paper is not what you contracted for, if the reproductions are poor, or if the print is smeared do not accept the work; insist that it be redone.

How Important Is a Brochure?

Brochures are used as a tool to introduce the artist and the work or used as a tangible reminder. They are good promotion to give or to mail collectors, prospective collectors, dealers, and anyone else who shows an interest in the artist.

Brochures are very useful, but they are not essential. Often you can accomplish the same thing, providing a tangible representation of yourself and your work, with a high-quality exhibition announcement or a published magazine article.

The biggest disadvantage of a brochure is that it can become obsolete very quickly. As your work changes or your credentials become more impressive, your brochure ceases to adequately represent you.

Creating a Portfolio

To create a professional looking portfolio, begin with a looseleaf binder that appears serious and substantial. Do not use a binder that says "scrapbook" on it. Do not use a cover with any kind of pattern or frivolous design. The best are simple, leathercovered binders. Inside, use plain scrapbook or photo album pages covered with acetate; the acetate will protect the material underneath it.

The material that you put into your portfolio should only be the most important representations of your art career. A resume is essential, and it should be neatly typed. Include invitations from major solo and group shows, especially those that include reproductions of your work. Include favorable reviews of your work and feature articles from newspapers and magazines.

Newspaper clippings often look awkward because they have odd shapes and the paper yellows quickly. These look more impressive if you trim and arrange them on a standard $8\frac{1}{2}'' \times 11''$ (22 cm × 28 cm) format and have them photocopied. Include a photograph of yourself and enough reproductions of your work to give the viewer a strong impression of what you do. If you don't have enough reproductions of your current work in invitations and clippings, include several $8'' \times 10''$ (20.3 cm × 25.4 cm) photographs so that your work is well represented.

Keep your portfolio current. Add new credits and photos; remove those that are old and out-of-date. Update your portfolio at least once a year. Do not include souvenirs, mementos, or snapshots, since this is not a scrapbook.

In arranging my portfolio I usually put my most current work first, but this is not essential. The most important element in designing the portfolio is to make it as interesting as possible. I do this by alternating magazine articles, newspaper clippings, invitations, and photographs, which creates the impression of great variety. It is especially good to intersperse the black-and-white reproductions with the color reproductions.

All reproductions should be labeled with medium, size, date, and collection (the owner(s)).

In Summary

Whenever you create any promotional material, plan it carefully. Everything should work together. A strong career summary that you write for a press release should also fit into your brochure or portfolio. The $8'' \times 10''$ (20.3 cm x 25.4 cm) photos of your work for your portfolio should also reproduce well for newspaper publicity. Plan your promotional material thoroughly, execute it carefully, and keep it available. You will continually find new and important ways to use it.

WHO IS
THE COLLECTOR?

By popular opinion the art collector is a rare and lofty bird. Invariably "high society," he lives in a mansion and rides in a chauffeur-driven limousine—in the stereotype, the collector is a man. When he is not visiting galleries in search of new works to add to his collection, he is sitting beside his library fireplace, cognac in hand, admiring his latest acquisition.

Maybe in some other time and place this was a true portrait, but in today's America, it is sheer fantasy. The support of the current art world comes from "middle America"—the men and women who grew up with magazine illustrations on the wall and Perry Como on the radio. They have earned enough money to pay for all the necessities and the conveniences; now they want luxuries, and right at the top of the list is being personally involved with art.

I look to these people to support my career. I respect them and I value them. Many admit that they don't know much about art and they are sincerely trying to learn more. My collectors include secretaries, teachers, bar owners, housewives, plumbers, and electricians as well as doctors, attorneys, and bankers. It is their appreciation and confidence in my art that makes it possible for me to continue working as an artist.

The Many Species of Collector

There are many kinds of collectors, both private individuals and public institutions, who are important to the art world. I have compiled a list of seven categories.

First is the *Beginner*. This person has never bought a piece of

art before. Often he or she has never visited an art museum or gallery and has no formal knowledge of art; probably the person feels somewhat intimidated by art, artists, and art dealers. Usually the way this type of collector comes to art is through a friend or relative who is an artist. Because the artist is a friend, the person can study the work in a relaxed way, feeling free to ask questions, and learning through continual exposure to appreciate the work and to feel comfortable with it. At last, the person sees a piece of the friend's work that is especially appealing and decides to buy it, thereby becoming an art owner.

In most cases this initial venture into collecting will lead to further involvement in the art world. The new collector, who was always interested in his or her friend's art career, now becomes personally involved and wants to see more work, to attend exhibitions, and to meet other artists and collectors. Usually this person will go on to buy more art.

Most artists start out with beginning collectors, the aunts, cousins, and neighbors who buy earliest pieces of work. Often we don't even think of them as collectors; the purchases take place in an informal way and the amounts of money are very small. However, these people can be the most important collectors in an artist's career, because they help us make the jump from amateur to professional. Because of their early involvement, they are often our most loyal fans through all the professional ups and downs that every artist encounters.

Second is the collector I call the *Individualist*, the "I-buy-what-I-like" collector. This person may have a Ph.D. in Art History or no formal background in art at all, but still is confident of his or her judgment and will not be swayed by fashion or criticism. If this collector likes your work, he or she will buy it regardless of what anyone else says and will proudly display it.

With a fair number of these first two kinds of collectors supporting your career, you can quit your job selling shoes or teaching school. They will loyally attend your exhibitions, buy your work, and endorse your career.

The third one is the *Social Collector.* This person buys what is fashionable, i.e., what everyone else is buying. There are large numbers of these collectors and since they buy en masse, they

have a great effect on artists' careers. Skyrocket successes are made by these collectors and careers are destroyed by them.

I think every artist has visions of being the darling of the art world, of having sellout shows and more social invitations than one could possibly accept. I have never had a sellout show and I must admit that I feel a twinge when I attend someone else's exhibit that is a smashing success. After careful observation, however, I have realized that these bright social successes in the art world are often short-lived. The artist who has a sellout in January may not sell a thing in August.

The reasons for one artist or one style of work to be fashionable are elusive and unpredictable. In New York there are individuals who are powerful enough to determine fashion by themselves; a handful of critics, collectors, and museum directors can recognize obscure artists and turn them into sensations overnight. In Denver the social movers are not so obvious. There are no major art critics and the museum pays little attention to local artists. Nonetheless, there are large numbers of social collectors who move from one artist to another in waves.

No one fully understands what makes an artist a social phenomenon. If it should happen to you, be grateful that people are buying your work and put the money in the bank. The biggest danger is that an artist whose work becomes a social rage might believe that this is a permanent success. The artist raises the prices of the artwork, then raises them again, and the work keeps selling. The artist moves into a bigger house and a more elaborate studio, and acquires a new car, a sailboat, a mountain cabin. Then one day six months, a year, or three years later the artist has a solo exhibit and nothing sells. There is no money in the bank, the artist's prices are too high for the market, and the social collectors have drifted off to a new phenomenon.

The fourth kind of collector is the *Investor.* The true investor is interested in art only as a way to make money, a lot of money. This person buys and sells expensive artwork by proven masters. Rarely is the investor interested in an artist without an established reputation.

It is important to remember that although there are relatively few art investors, every collector likes to think that each art

purchase is a good investment. In planning and executing your promotion, always try to make collectors feel that you are becoming more successful and your work is growing more valuable.

The fifth collector is the *Commercial Institution.* More and more banks and large corporations are acquiring art collections. The focus and scope of these collections vary, but they often include work by contemporary artists. Usually, one person is in charge of making contacts within the art world; often a public relations director, and/or a committee gives final approval on the works of art. You can find out about specific institutions by following the newspapers or by contacting the institution directly.

Sixth is the *Interior Designer.* Interior designers and architects are often expected to select and purchase artwork in addition to designing an office space or home. The type of work they buy generally depends on the taste of the designer and the total design of the space. Designers of commercial spaces are often an excellent market for large, nonobjective works.

The seventh collector is the *Museum.* Many museums are actively involved in collecting art by contemporary artists, either national or local, and they have a fund especially for such acquisitions. To find out about a museum's attitude toward purchasing art by living artists, contact the curator of contemporary art or the curator of a particular field such as prints and drawings.

The Collector's Point of View

The main thing to remember about collectors is that, like artists, they are people. They have many different reasons for buying art, but for each collector the act of purchasing a painting or sculpture is a serious involvement with the art world. I have interviewed several collectors in an attempt to understand and pass on their feelings about art, artists, and the collector's role in the art world. Following are excerpts from my conversations.

Bob Bucher is an investment banker who recently moved from

New York to Colorado. He is fascinated by the art world he has discovered in his new state.

"I am not a regular gallery-goer. If I'm invited to an opening and I like the piece of work that's on the invitation, I try to go. I like to look at art and, living in a new place, I appreciate the chance to meet people.

"It is interesting to talk to an artist, but the buyer is shy. He knows that the artist has already said what could be said on the canvas.

"I sort of forced myself to get into art. I can't remember anything on the walls when I was growing up. Later I felt I *should* like art. The first piece of art I acquired was a canvas my sister-in-law gave me. I knew her work and was comfortable with it. I didn't like the idea of sticking something on the wall just because you're supposed to have things on the wall.

"I buy work that I like and want to live with. I like strength in art. I like art that is individual. I once bought a piece of work at a group show. Later I went to the artist's studio and saw a whole gallery full of the same pictures. It was very disappointing.

"Decorating can be a problem—like trying to hang the bright, bold colors of contemporary art next to a delicate Persian rug. I always consider where I will hang a new piece of work.

"There was a gallery owner in New York who kept calling me whenever she got a new piece that she thought I would like. I knew she was hustling me, but I liked that attention. The collector wants to feel important."

Mary Ella Fetzer is the director of a pre-school. She studied art in college, but says she puts that behind her when she buys art.

"I have trust in my judgment. I would not buy something that someone told me was good if I did not like it. I have to respond to it emotionally.

"I like to own art because it's something that I can't do myself. I see a painting and I don't know how the artist got there, but I can share it. I can share that part of the artist.

"I doubt that I would spend a lot of money on a painting without knowing something about the person who did it.

"When I bought my first painting, I didn't have any art and I

wanted something nice and important. That he was a young artist and a good one appealed to me. I liked the idea that I could buy something that I could afford then and maybe it would increase in value."

Rose Landers is a housewife and a patron of many civic and cultural activities. She has been especially generous with her interest in and help to beginning artists.

"Why do I help young artists? If we don't help them get going, it's such a terrible struggle for them. If you have a father like Wyeth, it's a different story. But who's going to know an artist named Kontny or Tate if no one helps them.

"We always had some pictures when I was young. In those days people didn't collect art to put on the wall. We had photographs of the family all over. Now we hide the photographs in the bedroom.

"The first painting we bought was by Swenson, a well-known artist in Chicago. Marshall Field was carrying Swenson's work but we couldn't afford it. Then we saw this painting in a pawn shop; it was hanging on a wall covered with dust. We bought it for the price of the frame. I took it home and called the museum to find out how to clean it. We bought that before we had a dining room set.

"I buy a painting because I like it. Sometimes it's the color or texture. Sometimes it's the subject-matter. It doesn't matter if it's $5 or $500—if you like it, you should buy it.

"I try not to go to opening nights. I like to go when the gallery is quiet and I can observe and take my time. I always go to shows of artists I am interested in.

"I think you are very much influenced by the personality of the artist, but if I like the work, I don't care if I never meet the artist.

"I feel the same way about art that I feel about music. I couldn't live without either one."

Ed Klamm is a photographer. He doesn't consider himself an art collector, just someone who likes to have beautiful things on the walls.

"The first art I saw was when I was living in New Orleans. We

used to go into art galleries because it was something free to do.

"The first picture I bought was a picture of me, but I didn't buy it because it was of me. It was a painting of someone day-dreaming of something serious, of something he wanted—that's how I related to the world at that time. One of the things that keeps me interested in the painting is that it's not the same every time I look at it. It didn't matter how it was done or what the colors were. When I found the piece that I really wanted, money wasn't a consideration.

"Technique is a lot more important to me now because I've learned more about it.

"It would be awful if there was no art on my walls. It's a recognition of that part of your senses, that it's important that you have something nice for your eyes to see. I'd rather see the walls overloaded with knickknacks and postcards than bare and sterile.

"I don't care how other people react to the art I buy. It's nice if they admire it, but I don't really care."

In 1971 the Johns-Manville Corporation bought the 10,000 acre Ken-Caryl ranch in Colorado as the new site of their world headquarters. Recognizing that such a large development would greatly alter the environment, the corporate management decided to preserve and capture the original look and feel of the ranch in artwork.

Fil Giuliano, manager of art and production, commissioned thirteen local artists to interpret the ranch in their own media before construction began. She talks about the Ken-Caryl Collection and Johns-Manville's other involvement in collecting art:

"We wanted a representative group of painters, sculptors, and photographers. It was important that they be local artists. We didn't go to any abstract artists because we wanted to show what this ranch was like before we came here. If we had used abstract artists, management would have probably taken the money back and kicked us all out.

"First we talked with people who were familiar with the art community. Then we visited artists' studios. After we chose the artists, we brought them out here and drove them around to see

if they would be inspired. Then it was no holds barred; they worked however they wanted.

"In my position where I'm buying for the company, I have to trust my own judgment. I look for good art that is also a good investment. If I make a mistake, it's really a bad thing. I think this collection has doubled in value since we bought it. One piece of sculpture that I bought for $5,600 is now selling at the Kennedy Galleries for $22,000.

"We are creating an art gallery in our main building where the collection will be permanently displayed.

"Johns-Manville also has a collection of 600 contemporary lithographs. These were purchased by the interior design firm that did the building. They are hung throughout the offices and halls.

"One of the values of these prints is that they bring art to the employees. There are 2,000 people here and they are so isolated, being this far from the city. You've got to have something that will stimulate them."

Architect Fred Mikawa is president of Mikawa + Hinkley Associates. His firm specializes in designing restaurants, planning both the exterior and the interior, down to the table tops. As part of his work, he purchases art for his clients.

"Probably 80% of our work is in restaurants and clubs. Up until now most of the restaurants didn't want to allow money in their budget for walls. Initially everybody was into how many tables and chairs they could squeeze into the space, but the competition is so severe that they have had to start thinking more about the decor.

"I personally like contemporary art, but what we choose depends on the restaurant. We have done everything from a barn to a bank vault and the art has to fit in with the total atmosphere.

"I think restaurants are becoming more aware of art all the time and the patrons are too. The art contributes to the total experience.

"People are using art more in their daily lives. Art in restaurants and places of entertainment is just an extension of that. We did a health club where we used Italian leather couches, oak paneling, and original art.

''Not only does art look good, but it's a good investment if we pick the right artist. I watch the artists and the direction they are going. The restaurant will usually trust my judgment.

''In general I try to work through the galleries; I don't have a lot of time to see individual artists. Most of the galleries around here know what I like and will contact me if they have something they think I will like.''

Coping with Rejection

The private collectors I interviewed all indicate that they buy art for personal, often emotional, reasons. This is typical of the collectors I have dealt with, and it has important implications for the artist. It means that no matter what kind of art you create, it is not going to appeal to everyone. Furthermore, each collector responds differently to every piece of art; even among one artist's work, a collector will like some pieces better than others. So when someone says he or she doesn't like *your* work, you have to keep this rejection in a healthy perspective.

When a collector rejects a piece of work, it might be for any one of a dozen reasons. The painting might be too big for the living room; the subject may not be appealing; the color might be too bold; the mood could be too sentimental or not sentimental enough. Maybe the collector loves it, but his or her spouse thinks it's horrible. Any of these reasons is valid for a collector not to purchase a piece of work, and you have to respect the collector's decision.

However, there is a tendency among artists to feel that if people reject their work, it means that the work is not good. You must decide yourself if the work is good—judging your own work is part of being a professional. Once you have made your decision, you have to have faith in your judgment.

Your goal in meeting and getting to know collectors is to find those whose personal taste supports your judgment. If you meet a collector who doesn't respond to your work, don't try to change the collector's taste and don't try to change your work. Politely say good-bye and look for another collector.

CHAPTER 6

THE CARE
AND FEEDING
OF COLLECTORS

Why should you want to meet collectors? This question is basic to my whole approach to promotion. I, like most other artists, would like to have a representative who could handle the business aspects of my career. Up to now, however, I have not found anyone I can trust who can do a better job than myself. I have galleries that sell my work, but as far as my total career is concerned, I maintain personal control. And the foundation of many artists' professional career is their collectors. The people who buy my work enable me to keep painting.

There is another aspect to knowing my collectors besides business. I create a very personal kind of art; every image is special to me. With great care I choose the pictures that will finally be framed and sold. It is important to me that the people who buy my work care about it too. Knowing these people and being able to talk with them about the work reassures me. It makes my drawing and painting more meaningful to me.

How to Meet Collectors

Collectors are everywhere. I have met them at cocktail parties, weddings, and Bar Mitzvahs, other artists' studios, art exhibits, lectures, workshops, and in charity and professional organizations. It is a matter of learning to recognize a collector when you see one and of determining if this collector might like your work. The only way to learn is through practice.

How do you find out if a stranger is an art collector? You ask —usually in the most subtle way possible. Suppose you are at a cocktail party and you find yourself next to a stranger. You

could blurt out, "Are you an art collector? I'm an artist and I was wondering if I could sell you something." In most cases, though, the stranger would think you were rude or slightly crazy and walk away.

It is better to approach the subject obliquely. If you ask the stranger, "What kind of work do you do?," the person will usually answer your question and will probably ask what you do. You say, "I am an artist." Then the stranger might ask, "What kind of art do you do?" or "Do you show with a gallery?" Once you have started talking about art, it is easy and comfortable to ask if the person collects art.

In an art-related situation, i.e., an exhibition or class, you might ask, "Are you an artist?" Non-artists are usually flattered by this question.

Once you know the person is a collector, ask, "What kind of work do you like?" Most art collectors are delighted to talk about the work they own and the work they generally like.

One of the best pieces of advice I have ever heard about how to develop a conversation and how to make a favorable impression is to ask people to talk about themselves. Show an interest in the other person. Ask about the person's interests and opinions, and really listen.

In a conversation with a possible collector, you want to find out if the person is interested in art and collects it, and what kind of art he or she likes. Also, you should say that you are an artist so that the person will recognize your name in the future.

What if you are basically a recluse? You might be a solitary kind of person—you might hate parties, groups, and organizations. Many artists are shy or unsocial. This is natural because art is, for the most part, work done in solitude. If you are a recluse, you have to try very hard to get out and meet people, and to act like you enjoy it.

There are two basic approaches that you can use: the community approach and the special interest approach. With the community approach the goal is to meet all the potential collectors of your work in your community. It is usually impossible to meet them all, especially if you live in an urban community, but that is what you should be working toward. Take an active part in

church, PTA, or community action groups. Work for a political candidate. Volunteer to help with some charity organization or cultural group. Give lectures or lead workshops in art or any other field in which you have expertise.

You must be a serious member of any group that you join, otherwise people will know that you are there for selfish reasons and they will resent it. Pick organizations and activities that you are genuinely interested in and those you will want to work for. At the same time, choose those that will provide the opportunity for you to meet many new people. An important warning: Do not become involved in so many activities that you no longer have time to do your artwork.

The other approach, the special interest approach, is good for artists whose work lies in a particular area. This approach is to seek out collectors who are specifically interested in your subject area. For instance, if you are a wildlife artist, you might do volunteer work for the local zoo, museum of natural history, or conservation group. Working actively for the preservation of one particular animal might be more effective than joining a large organization like the Sierra Club. Again, pick activities in which you are sincerely interested and which will introduce you to new people.

There are unlimited possibilities. If you paint or sculpt children, help raise money for a children's hospital or center for retarded children; work with an adoption agency or an organization to prevent child abuse. If you paint flowers, join horticultural groups, help with your local botanical garden, or take classes in gardening. If you paint musicians, work for the local symphony or help organize a jazz or folk music festival. If you do historical paintings, join historical societies and help with pageants.

Taking a class is a good way to meet people. Art history and art appreciation classes, particularly adult education, are especially good because most of the students are interested in art. Involvement with an art museum can be excellent, but first be aware of the museum's orientation. If you are a traditional artist, you won't get much help from a contemporary museum. If

you paint large, nonobjective canvases, a museum of American western art would be a dead end.

Are rich people more likely to buy art? I don't think so unless the art is very expensive, but many artists disagree with me. I heard of one artist who paid $50 to go on a house tour, figuring that people who could afford to spend $50 just to look at old houses were worth meeting. Another artist moved into a very expensive home in a country club neighborhood, presumably because it would improve his image and his new neighbors would be better able to afford his art.

Edgar Britten is a sculptor who does large architectural pieces. He says that when he started out, he and two other artists who were interested in architectural commissions formed a group. They created a portfolio of photographs of their work and then approached various architects. It was a very successful way of meeting the people who would be interested in buying their work. The same kind of approach will work for commercial institutions and museums. Telephone the organization to find out who the right person is to talk to, and ask if he or she would be interested in seeing your presentation. Always make an appointment before you go in. Take your professional portfolio of photographs, resume, and reviews with you. You will probably have to approach several institutions in order to make a few good contacts.

Excellent sources of new collectors are the friends, relatives, and collectors you already know. Tell everyone you know that you love to meet new collectors. Invite friends and relatives to bring new collectors to meet you at your studio.

It is important to be socially active and at least appear to be having a good time, but being drunk and disorderly in public will not help your career. You want people to meet and remember you as a professional artist, not as the life of the party.

Sometimes I get tired of constantly worrying about my public image, but being an artist is being a public figure. Creating a reputation for notorious behavior might spread your name around, but it will rarely help you sell your artwork.

Creating a Mailing List

I have a card file that contains names and addresses of my collectors and other interested persons; this is the cornerstone of my business. I have been building this file for years, ever since I first decided to be a professional artist. Whenever I meet a person who is interested in my work, I get his or her name and address and I add another card to my file.

I use standard 3″ × 5″ (8 cm × 13 cm) file cards. At the top of the card I put the person's name; if it's a married couple, I include both the husband's and the wife's first name. I record the address including the correct zip code and the phone number if I have it. I jot down some identifying information—profession, where I met the person or who referred that person to me, what artists' work the person collects. I also note which of my galleries have this name on their mailing list so that there won't be duplications in mailing. If the person owns any of my work, I note the title, medium, size, price, and date of purchase for each piece.

I keep the cards in alphabetical order in a box on my desk, easily accessible. I am very conscientious about keeping the cards up-to-date. Whenever I hear of a change of name, address, or phone, I revise the card.

This is my basic mailing list. I refer to it when I want to contact a particular person, when I send invitations or other promotional material, or when I want to refresh my memory about a certain collector. Every professional artist should have a complete and accurate mailing list; the card file seems to be the most efficient form.

How do you create a mailing list if you are a beginning artist? Start with the people you know—the friends, relatives, and neighbors who are interested in your work. Include everyone who owns a piece of your work, either by gift or purchase. It is important to include people who really like your work even if you are sure they will never buy any. Their enthusiasm may encourage someone else to buy.

Next include those people who you think should know about your work: art reviewers for newspapers, magazines, radio and

television; art magazine writers and editors; art agents and gallery personnel; museum curators; art teachers and art historians. In Denver, and probably most other cities, there is no source for such names except individual research. Read newspapers and magazines, ask friends in the art community, consult the *Fine Arts Marketplace* and other resource books in your local library.

Ask your friends for names of people they think will be interested in your work. Other artists can be especially helpful. Read newspapers and magazines for names of collectors. When you get the name of a collector, try to find out what kind of work that collector likes. Do not include collectors who like work that is completely different from yours, unless you know that they are interested in you and your career.

There is no particular length a mailing list ought to be. Sometimes you will want to send a limited number of invitations for a show. In that case, go through your card file and pick out only those people who are most likely to respond to the invitation. If you feel that your own list is too short for a particular mailing, you can add membership lists of various organizations. Here are some possibilities: art museum membership; symphony and theater patrons; interior designers; architects; doctors, lawyers or other professionals; management organizations; country club members; church members; political organizations; organizations related to your subject-matter. Choose those that are most likely to respond to your work.

Keeping in Touch with Collectors

Meeting a collector is only important if you develop a further relationship with that person. You want the collector to remember your name, to be interested enough to see your work, to buy your work, and to pass on his or her enthusiasm about you to other collectors. This rarely happens from just one meeting. It is usually the result of an initial meeting and continual contact by mail, by telephone, and in person.

After I meet a collector who has never seen my work, but would like to see it, I send printed material with reproductions— brochures, invitations from past exhibits, etc.—and/or I invite

the person to my studio. I usually prefer the personal contact of a studio visit. (You must learn to distinguish those people who really are interested in seeing your work from those who are just being polite.) Whenever I send out invitations to an exhibit, I send one to that person, often including a hand-written note. Whenever possible I send invitations to everyone in my card file, even those who live out of state. When a review or other article is published about my work, I have reprints made and send those. If an article about my work appears in a major magazine, I buy extra copies of the magazine and give them to my collectors and potential collectors; I deliver as many of those in person as possible.

Doug Dawson sends a thank you note to every person who purchases one of his paintings. He says that the collectors are extremely grateful for this courtesy. He believes that the thank you notes are often responsible for further purchases. Many artists send Christmas and New Year's cards to all their collectors.

I try to maintain a friendly relationship with my collectors, many of whom are, in fact, my friends. They sincerely want to know about my new work and the progress of my career, so I try to keep them informed. If I do a piece of work that I think a particular collector would like, I call and invite the person to come to my studio to see it.

There are dangers in being too friendly with one's collectors. I know one artist who for years was very generous about inviting collectors and students to visit him at his home. Over the years more and more collectors and students came, bringing with them more collectors, students, friends, and curiosity-seekers. It got to the point where the artist was spending all of his work time with the guests, and his wife was spending all day in the kitchen. In one day twenty-nine people came to visit and the artist's wife served coffee and/or meals to nineteen of them. After that the artist and his wife went into seclusion, discouraging even their closest friends' visits.

I heard a second story from the ex-wife of another Colorado artist. This artist's main interest in life was mountains; he painted and climbed them. He, his wife, and young son lived a

quiet, rural life. Then his work started to become popular and he was in great demand for painting workshops and exhibitions. That he was a mountain climber and an artist, as well as young, tall, and blonde proved to be an overwhelming attraction for swarms of women students and collectors, who came to his home and studio, phoned, and even sent obscene letters. The marriage ended in divorce.

I have also heard of artists plaguing their collectors. There is one photographer who is notorious throughout Colorado and New Mexico for stopping at a patron's home for a short visit and then staying for months. He generally rearranges the family's life-style as well as their furniture to suit his convenience, never contributes food or money while he is staying there, and leaves only under the threat of physical violence. His saving qualities are that he is an excellent photographer and he tells good stories.

Most relationships between artists and collectors are not so dramatic. Generally they are just as friendly or formal as the artist chooses to make them.

The time and effort I spend meeting and getting to know collectors I consider an investment in my career. I am very patient. If someone expresses interest in my work and doesn't buy anything for years, I still send invitations to my shows and go out of my way to be friendly to that person at parties and exhibits. The right time has not come yet for him or her to buy a piece of my work. Of course, I need collectors who will buy my work now, but I will have more work to sell in five or ten years and I will need collectors then too.

CHAPTER 7

HAVING
AN EXHIBITION

The best way to show a large portion of your work to many collectors is to have an exhibition. A one-artist exhibit helps to establish your credibility as a professional artist, and it provides an opportunity for public exposure of your work. If you plan your exhibition well, it may also bring you a fair amount of financial profit.

Many artists who would like to have an exhibit are afraid that it would be too difficult to arrange the exhibit themselves. Following are interviews with three artists and one patron who all say that with careful planning any artist can have a professional solo exhibit that is both successful and fun.

An Exhibit in Your Own Home

Watercolorist Libby Cottingham tells about her own experiences this way:

"I think a show in your own home is really good for artists who are just starting out. I wanted some way of selling my work before I was ready to go into a gallery. I have had two shows now, both in my home.

"One of the most important things is to pick a good day. I chose Sunday afternoon from 1–4. I chose a weekend so that husbands and wives could come together. I think May to October are the best months. November, December, and January are bad because of the holidays.

"I sent a simple, formal invitation:

You are cordially invited
to a private showing of
watercolors
by Elizabeth Cottingham
date time
address
Refreshments will be served.

"I included a map with the invitation because my house is hard to find. On the map I wrote, 'If you would like to bring a friend who would be interested, feel free to do so.' I am very careful to make it known to my friends that this is a business venture rather than a party. I invite people who have bought my work or expressed interest, not friends who are not interested in buying.

"Invite twice as many people as you want to come. I invited 200–250; between 100 and 150 showed up. Don't mail invitations too early; about two weeks ahead is good.

"All the food has to be done ahead. I started making and freezing hors d'oeuvres three weeks ahead. I served hot and cold hors d'oeuvres and champagne. Champagne is elegant and simple. You don't have to worry about ice cubes, mixing or storing punch or mixing drinks. You should also have soda or iced tea for people who don't drink. I always have potato chips and dip in back, in case I run out of hors d'oeuvres.

"I rented champagne glasses and bought flowers. I wanted a formal atmosphere in order to sell more expensive pieces.

"I hired someone to serve the food and champagne. It took all her time just to carry food and champagne from the kitchen to the serving tables. I put food in all three rooms so that people wouldn't congregate in one place. I staggered putting out the food so that it wouldn't all go at first.

"About three days before, I took all the furniture out of the living, dining, and family rooms except lamps and a few tables. I laid all the pictures on the floor and figured out how to hang them. It took five or six hours just for hanging. Even after you get them all hung, sometimes you'll want to rearrange them.

"Be careful of lighting—look out for dark corners and glare

from windows. Unless you have a large dining room, do not hang work where the food is. Be careful of hallways—don't hang pictures in the hallway to the bathroom. It is important for people to be able to move around.

"I have found that pictures sell better if they're hung in groups rather than in a straight line. They look more interesting. People will sometimes buy more than one from a group. I hang all the flower paintings together, all the landscapes together, etc.

"I try to have thirty-five to forty-five pieces, about half framed and half matted. Vary the size of paintings. Give people a choice. My pictures range from $15 to $225.

"Don't forget labels for the pictures and sold stickers. Make a list before the show of all paintings and their prices without sales tax and with sales tax. This makes it easier to write up sales during the show. Make up your mind ahead how you want people to pay. I ask them to pay in cash or in two payments.

"My husband was there to help with sales, but most people wanted to talk with me. You can never anticipate who is going to buy. Don't give more attention to one person than another. Be sure you get the name, address, and phone number with each sale.

"You have to have help at the show. Besides someone to serve the food, I have someone to answer the door, have people sign the guest book, and answer the phone. It's important that whoever answers the door is friendly and helpful.

"The first show cost $700 including all of my frames; my gross sales were $1600. I learned to cut costs for the second show; it was less than $500 for expenses."

An Exhibit in a Patron's Home

Elaine Penny had an open house for artists:

"We thought it would be fun to have an open house for the holidays and to help an artist. We had the first show for an artist who was living in our guest house. We chose the first weekend in December and started working on the show a month ahead. The second time a printmaker came to us and asked if we would like to have a show. We started two weeks ahead—that wasn't really

enough time. The first show was 5–10 P.M. on a Sunday; the second was on a Friday. I don't think I'd try it on a week night.

"They were phenomenally easy to do. The biggest step is deciding you're the kind of person to have an art show.

"We sent out 250–300 invitations. About 150–200 people came. We let the artist invite anyone he wanted. We invited people we thought could afford to buy art; we partly used a list from church. Since it was a combined show and open house, we also invited some friends who wouldn't buy.

"It's important to keep the invitation list for the next show. Like a Christmas card list, you cross some people off and add others. We tried to eliminate the drunks from our list for the second show.

"The mail service seems to be getting worse. I don't think three or four weeks is too early to mail invitations around Christmas.

"We served wine punch, crackers and cheese, and fresh vegetables and dip, things that would taste good, but not be too expensive. It is essential to have people to help with the food.

"We helped the artists hang the shows, but we let them decide where each piece should go. I pulled curtains and closed doors to encourage people to stay where the art was. We insisted that the artists do all the pricing and that the prices be on the frames. Customers dealt directly with the artists.

"The first show didn't sell very well, probably because of the subject-matter—very contemporary, large paintings and nudes which were shocking to many of our friends. Also the artist pretended he didn't care how successful the show was. He said, 'Let's just do it for a lark and see what happens.' I didn't know until later that he really did care. I could have done better, like putting more research into the mailing list, but he said it didn't matter.

"The second show was better. The artist took in $500, which was a lot of sales because they were all very small, low-priced etchings, many of them unframed.

"We split the cost of the show with the artist. He kept all the sales. It cost about $200 for food, invitations, and decoration."

A Studio Exhibit

Painter Karen Nossaman had a show in an artist's studio:

"I couldn't really find a gallery where I felt like I fit in. It was either have my own show or nothing. I decided to have it in Ken Bunn's studio because our house is limited in wall space. I wanted it to be a big show because I had never had a show before. The spaciousness was an advantage and also Ken is a well-known artist. A lot of people came to my show because they thought they'd see him.

"I picked a time that was convenient for the Bunns. The opening was Friday night and I kept the show open to the public during the day for a full week.

"I made a time schedule. I started six weeks before the show designing my invitations. They were back from the printer four weeks before. I mailed out-of-town invitations 2¹/₂ weeks before and in-town ten days before. I made up a list of people who had expressed interest in my work. Other artists gave me names and brought friends to the show.

"Two weeks before the show I sent out press releases to all the papers. I wrote all the pertinent facts and took it to a writer friend for finishing. It included basic information about me and what would be in the show. I included two photos of work for each of the major papers. I also telephoned the reviewer at the *Post* and my husband hand-delivered the release to the *News*. I got a big newspaper article before the show and another one during the show.

"I mailed 200 invitations and gave about 50 to friends. Between 200 and 300 people came to the opening. A lot more came during the week. The newspaper articles helped a lot.

"For refreshments I bought two large slabs of cheese, crackers, several bottles of wine, and two kegs of beer. I returned a lot of the wine; liquor stores will take it back if it's unopened.

"Everything was framed two weeks before the show. I borrowed and set up track lights. I hung the show the weekend before it opened. That's another advantage of a non-gallery show; you have more time.

"I had two friends to help with sales at the opening. I chose

people who are very businesslike. They refused to take a commission; so I gave each one a drawing. Most people paid when they picked up work at the end of the week; so handling money at the opening wasn't a problem. I kept a journal of my expenses throughout the show. I spent $300 on the opening—about 20% of my gross sales.

"People didn't take me seriously as an artist before the show even though I had been in group shows. It was like graduating from practicing to becoming public. I didn't have the show to make money; I didn't expect to sell anything.

"Everybody was so helpful, especially other artists and gallery people. I learned not to be afraid to ask for help. There is no reason to suffer just because others have suffered."

A Public Show

Artist Veryl Goodnight held a show in a bank:

"The bank invited me to have a show there. It's a good place because it draws a high-income group of people and it's in my own neighborhood. I invited Glenna Goodacre to share it with me because I thought her work would be compatible with mine. With two of us we could do a really first-class show, which most galleries can't afford to do.

"I set the date with the bank a year in advance. We decided on December 1st, so it would have the feeling of a Christmas party. It was early enough so that people weren't 'partied out' and it gave them time to think about Christmas presents. March and April are terrible for shows because of income tax. It worked out that December 1st was on a Wednesday, so that's when we had our opening. The show stayed up for two weeks.

"We sent out 600 invitations. We used both of our mailing lists and the bank invited its top customers and board of directors. I sent hand-written notes to as many of my collectors as possible. We hired a public relations man, an art magazine editor, to do our publicity. He got us coverage on radio and television as well as newspapers and magazines. Between 300 and 400 people came to the opening.

"We had a full bar and hired two law students to work as

bartenders. We served hors d'oeuvres that were made by us and our friends. We hired guitarists to play during the reception and we handed out carnations and name tags at the door.

"We hung the show ourselves. We had about twenty paintings and ten bronzes each. We edited heavily; we wanted just our top work. We staffed the show with two salespeople for the full two weeks. We paid them an hourly salary and 5% of the total sales to split between them.

"We sold $10,000 at the reception. The opening and our salespeople cost us about 20%."

How to Plan Your Own Exhibit

Following is a list of considerations to help you plan your own show:

Date. As you might have noticed, there are conflicting opinions about what is a good time for a show. Choose a date that will be convenient for you that will give you time to finish your work, get your invitations printed and mailed, etc. Specific dates to avoid: major national, and religious holidays; major exhibits of other artists; the World Series, the Super Bowl, and other major sports events; and income tax deadlines.

Place. Choose a place with adequate wall space if you're a painter (floor space if you're a sculptor), enough room to accommodate a large number of guests, and make sure there is good lighting. If your home is unsuitable or if you would like a more public location, pick one that is accessible and attractive. Consider the availability of parking. Many commercial institutions are interested in lending their space for art exhibits; sometimes they are willing to share or even pay the full costs of promotion and/or a reception. Choose an institution whose representatives seem friendly and cooperative. Make sure they have insurance to cover your work against loss or damage.

Invitations and Publicity. The kind and number of invitations you send out depends on your own taste, budget, and mailing list. The same general guidelines I suggested for business cards,

stationery, and brochures apply. Your invitations should be simple and easily readable, containing only the pertinent information. If you include a reproduction of your work, choose an interesting piece that will reproduce well. The invitation should be large enough so that it does not look cramped.

Whether you send your invitation with or without an envelope depends on the impression you are trying to make; an envelope appears more gracious and people are less likely to overlook the invitation. The most important considerations are that your invitation be of high-quality—professional printing and heavy paper —and that it look professional. You want your invitation to tell people that this is a serious exhibit.

I think it is important to hand-address the invitations. Machine-addressed mail looks very impersonal.

When to mail your invitations depends on the quality of mail service in your area and the time of year; the Christmas season usually means slower mail. Generally I would suggest ten days to two weeks ahead; the invitation should arrive one full week before the show. Be sure that you use *correct* zip codes on your addresses; if your zip codes are incorrect, a good number of your invitations will probably arrive after the show is over.

If you are planning a public exhibit, you will want to have more promotion than just your invitations. I cover this extensively in Chapters 15–19.

Whatever kind of show you plan, one of the best ways to promote it is to talk about it. Tell your friends that you are going to have a show. Tell them that they are going to receive invitations or ask if they have already received them. Call your major collectors and tell them that they should be expecting invitations to a show. Be excited about your exhibit and encourage others to be excited about it too. This will make them feel involved and want to do everything they can to help your show be a success.

Refreshments. Again this depends on your own taste and budget. Whatever you decide to serve, plan it very carefully. Know well in advance what you need and get as much done early as possible. Plan ahead where you will store ice and perishable food and where you will chill drinks. Do not try to cook things on the last

day. Arrange for all of your serving tables and utensils in advance. There are stores that rent almost anything. Be sure you have plenty of glasses, plates, napkins, etc. If you are going to allow smoking, have enough ash trays. Some things, like arranging flowers and mixing punch, can only be done the last day; so take care of everything else well in advance.

According to people I have interviewed, you should have enough refreshments for at least half as many people as you invite. Generally it is better to have too much than too little.

Hanging the show. How much work you have and how you arrange it depend on your own circumstances. The main rule for exhibiting the work is that every piece should be easy to see. Every piece should be well-lighted, hung at eye level for the average person, and hung with plenty of space around it. If you are showing sculpture, use stands that are high enough for the average viewer to see the whole piece without stooping over. Use stands that will not fall over easily, even if guests lean against them. Don't have light cords where they can be tripped over.

It is important that you have enough floor space for people to move around comfortably. Make it easy for your guests to see the work; if your show is so crowded that people cannot move, they are not going to look at your work.

Do not try to finish paintings or frames on the day of your show; you will have too many other last-minute things to arrange. If you cannot hang your show until the day that it opens, have everything else done ahead and allow yourself most of the day just for arranging your artwork. Spread everything out on the floor or against the walls. Decide where you want everything to go before you actually hang anything.

Sales. Handling the sales at an exhibit can be a complicated business. Plan it ahead so it can be done quickly and smoothly. Decide who is going to manage sales and be sure that the person understands all of the details in advance.

Before the show decide on your prices and mark the price on each piece of work; do not change your prices during the show. Find out about your local sales tax ahead of time; contact your

state, city, or county departments of revenue for information. Have a receipt book and pens in a convenient place at the show. Write up a receipt, with a copy for yourself, for every sale. On the receipt write the name and address of purchaser, the title of the piece, the price and sales tax, and the date. If the piece is not paid in full, write the terms of payment on the receipt. Have a convenient place ready to store checks and cash. After a piece is sold, immediately mark it sold; this will save confusion about what work is still available for purchase.

Help with the show. The amount of help you need to run a successful exhibit depends on the size and nature of the show. The larger and more complicated it is, the more help you will need. Remember that most of the guests will want to talk with you, the artist; so you should have enough help to free you from other responsibilities. Special problem areas are sales, refreshments, greeting the guests, and answering the phone. Whether your helpers are paid or volunteer, choose people who are reliable, who will arrive on time, and who will work conscientiously throughout the exhibit. Drunk help is worse than none at all. If you plan an exhibit that goes on past the opening reception, either you or someone else must continue to be there at all times to greet people, answer questions about the work, and handle sales.

Additional suggestions. Make a timetable to cover all the preparations for the show and stick to it. Record your expenses—if you are a professional artist, they are tax deductible. Make a checklist of everything you will need for the show: picture hanging supplies; sculpture stands; lights; labels; sold stickers; refreshments; serving tables and utensils; ice; napkins; ash trays; flowers or other decorations; a guest book; a receipt book; pens; space for coats; a place to put the dog; etc.

Try to think of anything that might go wrong and plan ahead how to deal with that. If you have planned everything thoroughly and allowed yourself plenty of time, all you have left to do when the show begins is relax and have a good time.

CHAPTER 8

IS "SELL" A FOUR-LETTER WORD?

My definition of a professional artist is someone who creates art for the purpose of selling it. It is the intent to sell that distinguishes the professional from the hobbyist. There are other definitions, but selling is inherent in all of them. Why, then, do so many professional artists pretend that they do not care about selling their work? Why do so many artists try to remove themselves from any involvement with selling?

There are many reasons. We are still operating under the feudal mentality that commerce is ignoble. There is the mystique that great art sells itself—the belief that if you have to "sell" a painting, it must not be very good. We feel that art is like sex: to do it for money takes away its esthetic value.

Whatever the reasons that artists pretend they are not business people, it is a very non-productive attitude. The basic reason for selling work is that artists have to make a living. Artists have bills to pay. Every month there are food, rent, utilities, transportation, supplies, frames, etc., that must be paid. If artists are not independently wealthy and are not selling their paintings, then they are forced to take another job; this often means that there is no time or energy left to be artists.

In our society, money is a major guide for measuring success. To the public at large, an artist who is making a lot of money selling paintings or sculptures is a successful artist; there is also the myth that if a painting or sculpture costs a lot of money it must be a good piece of work. We don't have to accept these values in our own personal lives, but we must acknowledge that they have an effect on the developing reputation of every professional artist.

Finally, we must consider what the sales transaction means to the collector. Writing out the check that pays for a painting is an act of power; it is a public statement of the collector's taste and an endorsement of the artist. It is a solid involvement with the art world. Receiving a painting as a gift is rarely as exciting an experience as actively choosing that piece, writing out the check, and assuming possession of it.

Pricing Your Work

When you first start pricing your own works, visit local galleries and see what other artists are charging. Notice the price, size, and medium of the work, and ask about the background of the artist. Your prices should be compatible with artists whose work and credentials are similar to yours.

Generally, prices are based on these three elements: medium, size, and artist's reputation or credentials. Traditionally, oils and acrylics bring the highest prices of two-dimensional works, with the prices decreasing respectively for pastels, watercolors, drawings, and prints. Prints vary with the complexity of the process—the number of plates—and the size of the edition. Sculptures reflect production costs and size of the edition. Within any medium, large pieces bring higher prices than small ones. Artists who are well-known receive higher prices than beginners.

Often these seem to be meaningless distinctions. A graphite drawing can be just as fine as an oil painting. A tiny painting can involve just as much work as a large piece. An unknown artist can be as skilled as an established artist. However, in order for the wider art world to function there must be some uniformity in pricing, some basic standards for establishing the monetary value of a piece of work. It is possible to disregard these standards, but most artists find that it is simpler and wiser to accept them.

I suggest that artists start out with modest prices. Selling work is the best way to begin establishing a professional reputation and collectors are more willing to buy art from unknown artists at low prices. After you have sold several pieces and have begun

to be recognized as a professional, you can raise your prices.

The greatest danger for an artist in pricing work is raising prices too high too fast. There are fewer collectors who will spend $100 for a painting than $50 and fewer still who will spend $300. Don't be in a hurry to leave a price bracket where your work is selling successfully. Once you raise your prices, you can never lower them. Lowering your prices destroys the investment value of your work. No one wants to buy a piece of work that will decrease in value.

It is important, however, that your prices do rise regularly. Raise your prices when there is a major improvement in your credentials. This can be acquisition of formal credentials such as membership in the American Watercolor Society or the National Academy, or the result of regular exhibition of your work over a year or two. Raise your prices by noticeable amounts. Do not let them creep up $5 or $10 at a time. You want people to notice your price increases. This gives the impression that both your credentials and your sales are improving. If your prices are too low, i.e., much lower than comparable work on the local market, serious collectors will doubt your professionalism.

I cannot give any specific guidelines for pricing paintings and sculptures. Prices vary greatly from year to year and location to location. I recommend that you visit the galleries near you, study the prices, and set your own prices accordingly.

In setting your prices, think in terms of retail price, the price the buyer pays; anything else becomes too complicated. You should keep in mind production costs, framing, and gallery commissions; never sell your work for less than it cost you to produce. Another consideration is the quantity of work you produce; if you create a lot of work during the year, you can afford to sell it for less than if you only produce a few pieces. With these things in mind and an awareness of local gallery prices, set standard prices. If you decide that $250 is a fair retail price for an oil painting that is 16"x20" (41 cm x 51 cm), then price all your 16"x20" (41 cm x 51 cm) oil paintings $250. Do not alter the price. If you have bought an especially expensive frame, the price should be $250. Whether your gallery takes 30% or 60%, the price should be the same. Even if you sell the painting in your

own studio and pay no commission at all, the price should still be $250. Wherever a collector buys a piece of your work, he or she should be paying the same price—anything else is unethical.

Some artists feel that since the quality of their work varies, their prices should also vary. My opinion is that if a painting is not good enough to charge your standard price, the painting is not good enough to sell at all. Throw it away.

Making a Sale

We have all encountered high-pressure salespeople. They are determined to sell you something whether you want it or not, and often you buy it just to get rid of them.

This approach to selling is unnecessary and undesirable in the art world. A piece of artwork is a much more personal purchase than a vacuum cleaner or a set of encyclopedias. The paintings that collectors choose to buy express their own personalities; collecting art enriches their lives. My job as an artist-salesperson is to help the collector purchase what he or she *wants* to buy.

When someone comes to my studio as a potential buyer, I try to maintain a friendly, relaxed atmosphere. I keep in mind that I am there to help the collector. Often I serve coffee or wine, and try to provide a comfortable situation in which I can talk with the collector about my work and career, and about his or her interests in art. Then I suggest that the buyer wander around and look at the work, since I generally have several pieces hanging on the walls. I state that I will be happy to answer questions, but I try not to intrude. If the person asks about a particular piece, I answer the specific question or talk about some interesting aspects of the subject or technique of the piece. I don't mention price until the collector asks.

Sometimes there is a piece the person seems to want, but he or she is reluctant to make a purchase. I try to find out why the collector is hesitating. Maybe the collector wanted a new painting for the living room and this one won't work. I might say, "You like the piece. Why don't you buy it and find another spot for it? Probably you'll be redecorating in a few years anyway and you'll be glad you have the painting."

Maybe the price is more than the collector was planning to spend. I can say, "I really can't lower the price; it wouldn't be fair to my galleries. But I could let you pay it out over a few months."

Don't be afraid or embarrassed to discuss the purchase with the collector—ask about the collector's feelings and be honest in return. I often tell a purchaser, "This is a good painting. It's well worth the price." This is not arrogance; I believe that my paintings are good—I wouldn't sell them otherwise. Humility, especially false humility, does not sell art.

Taxes and Bookkeeping

When a customer decides to purchase a piece, handle the sale in a professional manner. Write up a sales receipt stating the buyer's name and address, the title, medium, size of the work, the price, and appropriate sales tax. If the buyer will be making time payments, specify the terms on the receipt and ask for the buyer's phone number for future contact. Some artists also include a statement about reproduction rights on the receipt, specifying that the artist retains all reproduction rights after purchase unless otherwise agreed and stated.

Unless you know the collector well, do not hand over a piece of work until the buyer has paid a substantial portion of the price. It is much easier to collect money before the merchandise has changed hands.

Keep accurate records of your sales. You'll need them, as well as thorough records of your expenses for computing income and sales tax payments. If you have questions about the best way to handle your bookkeeping or about taxes, hire an accountant or contact your local, state, or federal Department of Revenue. Accurate records are essential both for meeting your legal obligations and also for keeping track of your finances.

Every year the amount of profit you make should increase. It is not enough that your sales are increasing; with inflation and growing production and promotion costs, your expenses are also increasing every year. To compute your profit, subtract your total expenses from your total sales. Most artists do not make a

profit for the first few years, but it is possible and that should be your goal.

If sales do not improve after a year or two, analyze the various professional aspects of your career and decide what could be improved—professional image, promotion, the presentation of artwork, gallery affiliations. If your sales increase, but profits do not, try to find ways of reducing expenses and/or consider raising your prices.

Whether your sales are good or bad, or your profits high or low, you should always be working to improve the quality of your artwork. Continually analyze your own work. Go to galleries and look at other artists' work. Study books and magazines. Try new media, new techniques, new subject matter. Discuss your work with other artists you respect. An artist whose work is not growing and changing is an artist who is creatively dead.

Haggling over Prices

What do you do when a potential collector refuses to buy a painting unless you give him or her a discount? A person might suggest, "If that painting doesn't sell during the show, will you sell it to me minus the gallery's commission?" or "I like both of those paintings. If I take the two, will you give me a discount?"

In a time when garage sales and flea markets are a major source of entertainment, bargaining over prices has become a more widely-accepted practice. For many business people bargaining does not present a problem. For the artist, however, haggling over prices is nothing but trouble.

In the first place, if you have spent sufficient time and effort setting prices, they should be fair prices for you and the customer. If you lower those prices, you receive less than what the piece is worth, and you suffer a business loss. Secondly, it gives the impression that you are not sure of your own judgment and casts doubts on your professionalism in general. You suffer a loss of respect.

Lowering your prices and thereby charging less than your galleries for a similar piece means that you are undercutting your galleries. This is unethical and may lead to your being expelled

from your galleries. Also, other collectors, who have paid the full price, will be disturbed to know that you are selling work cheaper to other people.

The bargainer will say, "I'll never tell a soul." Don't believe it. The most important thing about the sale will be the fact that the person got a bargain, and the collector will probably tell people about it.

Not haggling over prices is something that I am adamant about. It is a personally degrading experience and can do your career serious harm. There is a great temptation to make a sale at any price, especially if you are short of money. It isn't worth it. If one collector is unwilling to buy a piece at your price, be patient. There are more collectors.

Investing in Your Own Future

As a footnote to this chapter, I would advise you to save some of your own work. Put aside some of your very best pieces. Save them for yourself. They are an investment in your future. If you are a serious professional artist, your prices are going to rise. What you paint today will be more valuable in five years, and your collectors believe this. Whenever they buy a piece of your work, they are investing in your future. You should be willing to make the same investment.

THE GALLERY
OWNER'S POINT
OF VIEW

The gallery is the center of the art market. Not only does the gallery serve as a marketplace, but it also provides an opportunity for the general public to see artwork that today's artists are creating.

It is possible for an artist to be financially successful without gallery affiliations. However, to achieve wide public recognition and acceptance of one's work, galleries are essential. With this in mind I have interviewed several gallery owners. In order for an artist to have successful relationships with galleries it is important to understand what art galleries are, who owns and manages them, and how they are run. In this chapter I interview four different types of galleries.

A Contemporary Gallery

The Jasper Gallery is a small, sophisticated gallery in an urban renewal section of Denver. The owners, Paige and Richard Reichbart, had been respectively a social worker and an attorney. They opened The Jasper Gallery six months before this interview and they have since devoted their full time to running it. They represent contemporary artists, both representational and nonobjective, with a strong emphasis on graphics. I asked Paige Reichbart the following questions:

Why did you open a gallery?
We wanted to be self-employed. Rich and I were always interested in art. We wanted to be involved in art, but we were not practicing artists. We felt that there was room for one more

semi-contemporary gallery in Denver. We wanted to have some impact on the public.

What were your first considerations in establishing a gallery?
We thought about what kind of art we wanted and what kind of compromises we would be willing to make in terms of taste and salability.

We thought about money. Opening any business takes a certain amount of capital. A gallery with consignment art takes less, but there is a fast drain on what you have. We decided to empty the savings account and do anything we could to stay afloat. In three months, when we were hitting rock bottom, we approached a bank. We borrowed $7000. We got it on personal rather than business credit. Most banks will not make business loans until you have been in business—viable business—for at least three years.

The money is going fast. But if the gallery's going to make it, it's going to make it because the gallery's done well.

What goes into running a gallery?
Time. This has had to be a complete passion. Just finding out what licenses and permits you need is time-consuming—four or five licenses just to open the door. I spent about three weeks compiling and revising my mailing list. I have had to become familiar with local and national artists. I've had to become familiar with local galleries, trying to understand what they do and why they are or are not successful. I've had to learn about bookkeeping, about framing, about the techniques of the artists we handle. It all takes time.

You have to learn to become assertive about contacting artists and following up on sales.

I have to balance three shows at once—the last, the current, and the up-coming show. I always expect that once a show is hung and the reception is over, that I can take a breather. There is never a breather.

You must accept the fact that every day off and every vacation will be tempered by seeing an artist or gallery.

What qualities do you look for in artists for your gallery?

We have to feel that there is freshness, quality, and vision, that each piece the artist does is unique.

We've been lucky; on the whole, everybody we've handled has been reliable. When new artists ask to show me their work, I usually tell them to call back the following week just to see if they'll follow through, to see if they are reliable.

What does a gallery owe an artist?
First of all you have to give them exposure in terms of wall space and time and publicity—by determining where to reach the best people. You have to familiarize people with the work of a particular artist and with the artist's name. It also helps to educate the public so that they have a knowledge of the various types of art and/or processes. By hanging an artist's work in my gallery, I am giving a public endorsement to that artist.

We owe the artist sales. I think one thing that's very important is that the gallery doesn't stay within its four walls. We have direct contact with designers and architects, encouraging them to think of us as a resource. We do some work as brokers, selling work from collections. If people know that we handle well-established national artists, it convinces them that our regional artists are more important.

What does the artist owe the gallery?
If we promote someone, we want that artist to produce so that we can have new work to show. We feel that we have a partnership with the artist in promotion. We expect professional photographs of work and a good, workable portfolio. We expect the artist to appear at openings. We need to feel that the artist is willing to make some effort to sell his own work.

We expect to get work in a very presentable manner—sturdy frames, well-cut mats.

We expect the artist to support the gallery. Our contract has an underselling clause, that the artist will not sell works out of his studio for less than we are selling them in the gallery. We expect the artist not to show work in direct competition with us, but we don't have an "exclusive" clause. Exclusives are ridiculous. The better known an artist becomes; the better off we are.

How do you approach sales?
I find that a lot of people dislike high-pressure selling. Many of them are somewhat paranoid about aggressive sales people, so I try to develop a "coffee pot relationship" with them. I say hello, offer coffee, and if they show any interest, I am available to answer their questions and give them the information they request. I see myself as a resource for them. Also I try to put them at ease so that I can do research of my own—"How did you hear about us?", "What kind of art interests you?"

Do galleries have other functions besides sales?
We want to educate people. You have to work with people where they are, with whatever knowledge and sophistication they have. You have to get people curious and excited and let them educate themselves. We are giving a print workshop this summer; we are organizing radio shows; we are planning traveling exhibitions. It is important to be doing things outside of the gallery.

A Traditional Gallery

The Sandra Wilson Galleries operated in Santa Fe, New Mexico, for several years before relocating to Denver. The gallery emphasizes a national selection of artists, most of whom are traditional in technique and subject matter. The gallery is a large two-level space in the building of an affluent, downtown hotel. Sandra Wilson, the owner, answered these questions:

How did you get into the gallery business?
It was almost a natural evolution. I bought my first serious art books when I was a teenager. I took art classes at a university. I worked for a gallery for six years and then, seven years ago, I opened my own. It was a chance to express myself through this end of the art business. It is a creative challenge to give artists a good forum.

What are the initial problems of starting a gallery?
They're always financial. It's always a major consideration in any business—making sure you don't start out on such a

shoestring that at the first downward slide, you are forced to fold. Managing money properly is a problem, trying not to be too extravagant in any one area, planning carefully what kind of advertising you are going to do. The strongest advertising for me has been word of mouth and the enthusiasm of my clients and my artists.

What should an artist expect from a gallery?
The artist should expect that the dealer is always striving to further the artist's career in making his work visible in a very respectable way, that the dealer will encourage people to start collections, that the dealer will approach corporations that have art collections.

He should expect that his works will not be stacked. Frames will not be mistreated. The works will be treated with reverence.

He should expect that records are kept, that the dealer is quite open about advertising budget and general business plans—that does not mean that the artist has a day-to-day say so. He has to give the dealer latitude to do things as he sees fit, and I can understand that with so many disreputable things happening with galleries, artists do get worried, but there must be trust.

The gallery's terms have to be the same for every artist it deals with. Everybody has to feel that over a year's time they are getting the same amount of wall space and the same amount of attention, the same amount of space in your ads—that is, in proportion with the amount of work the artist gives the gallery.

What should the gallery expect from the artist?
The dealer has to realize that the artist is not a machine that creates five paintings every month. However, the gallery is entitled to expect that it is getting a fair share of an artist's output in a year.

I expect quality work. A reputable gallery cannot ask people to invest in an artist who they do not think is sincere. Every artist who shows in this gallery is a statement of my belief in his work. It is a statement of my taste, my experience in the art world, my belief in who will be here fifty years from now.

I must be responsible for the artists I represent—that they are the finest in the field. The client must be assured that the dealer

wholeheartedly supports his artists; otherwise the dealer has no credibility.

If an artist's work changes as a result of a valid evolution, it should not be a problem from a sales point of view. It's more of a danger if an artist gets into something that sells and keeps doing the same thing. That is death to the creative spirit.

The gallery's main worry is that they will work to establish an artist and then the artist will start to sell direct—when the artist begins to feel he is known well-enough and doesn't need the dealer anymore.

What did you mean when you said you wanted to give artists a good forum?
I want to give professional artists a gallery that is dedicated to good quality. I am concerned with artists who are dedicated, serious, and whose life's work is to be an artist. These artists should know that their work will be presented respectfully in a businesslike way and in a convincing way, showing that it's not just merchandise off the shelf.

Do you feel there is an educational aspect to a gallery?
A large part of this business is educational. Just because someone did something on canvas or in clay does not make it art. I think collectors should be more judicious about what they buy.

There are techniques for judging art, what I call fine art rather than accidental art. You should look at craftsmanship. Is the canvas properly stretched? Does it have strong composition, focal point, clean, or muddy color?

I suggest to people when they get interested in art to go to a museum, buy books or check them out of the library. Look and study. Talk with a dealer; a bona fide dealer will be glad to talk with you.

I think the reason art was elitist in the past was that only the rich could afford to be educated—today everybody can be educated.

Do you have any advice for artists approaching a gallery for the first time?
Make an appointment; don't just drop in. Have good profes-

sional slides or photographs—a gallery cannot make a judgment on your work from blurred photographs. Watercolors should at least be matted and covered with acetate; oils should be framed. Work should be clean. The artist who presents his work poorly does himself a great disservice.

Ask questions of the dealer. Don't assume anything you are not sure of. The dealer should welcome the opportunity to clarify statements.

In writing to a gallery, send photographs. Only send the best work; the gallery is not interested in seeing anything other than your best efforts.

A Western Gallery

Tom and Diane Carson opened the Carson Gallery in 1972. The gallery is a wood-paneled suite in a substantial office building on Seventeenth Street, the banking center of Denver. The gallery specializes in western art. Tom Carson says, "The art reflects the area in which we live, Colorado mountains and wildlife and Plains Indians." He answered the following questions.

What was involved in opening your gallery?
We couldn't find a gallery in Denver we liked ourselves. We had bought a lot of art, but not in Denver. So we opened our own gallery.

We took a big sheet of yellow paper and wrote down what we liked and didn't like about existing galleries. We considered twenty-five to thirty locations. We wanted a space that would display a lot of art and we wanted to put as little renovation money into it as possible. Then we considered artists. We felt we needed some well-established artists to balance with other artists that we like, but that were not so well-established. Some well-established artists don't want to gamble with a new gallery.

What were the biggest problems?
The biggest problem has been communication and dealing with the idiosyncracies of the individual artists. Artists express themselves visually with their art, but not vocally. They do not make

their wishes and feelings known. That's why some galleries prefer not to deal with living artists.

We do not have a contract with the artist. If you can't make it without a contract, the contract will not make anything binding. It might help communication, putting things down in black and white.

We expect an area of exclusivity from the artist. In return we are here working and let our sales speak for themselves.

We try to indicate to artists that their involvement with our gallery is only one aspect of their career. They have to continue to promote themselves with us and nationally. They should show in galleries outside of this area and in national shows and competitions. We'll work with them, but we cannot perform the functions of a personal manager.

What kind of promotion do you do?
We feel one of the finest promotions is our sales. We have not gotten the return from paid ads that we hear other people have. We have cut down on paid advertising and sales have increased. We're more interested in maintaining a good showcase.

How do you approach sales?
When a brand new person walks into the gallery, we try to get him to express himself. Frequently people want to buy art, but they are frightened. The main idea is to understand the customer and what he likes. We are not in the business of selling art, but of helping people buy art.

We try to make the customer understand that he has as much input into the increasing financial value of an artist's work as the artist or the gallery. By buying work he likes, displaying it well, finding out about the artist, and expressing his own enthusiasm, the buyer increases the value of the work.

What do you look for in new artists?
When we are looking at a new artist, we ask him to bring in as much to show us as possible. We care very little about the artist's reputation when he comes into the gallery. We ask what the artist is trying to say. We rely on our own instincts. We like to see originality—creating rather than rendering, emotion rather than technique.

An Artists' Cooperative Gallery

Two years ago eight Denver artists decided that they would open a gallery to show their own work. In these two years The Brass Cheque has not only survived, but has grown in concept, space, and sales. It is a large, airy space in the same urban renewal area as The Jasper Gallery. Two of the artist-owners, Jackie McFarland and Lori Williamson, are interviewed here.

Why did you start the gallery?
Williamson: We thought, wouldn't it be nice if we had a space where we could display our own work? We all had had problems with galleries and we thought it would be better if we were artists dealing with artists.

How did you start the gallery?
McFarland: There were eight of us and we all contributed $250 for the first year. We chose this space because we liked the area. It's historic and it's cheaper than many parts of Denver.
Williamson: At the beginning we considered our image, what kind of image we wanted to project. We wanted this to be a friendly gallery and we wanted to show traditional work.
McFarland: We do all the labor ourselves. Each of us spends approximately five days per month sitting in the gallery, handling contacts with artists, doing artwork for printers, taking care of mailing, or other gallery work. One of us agreed to handle the bookkeeping; a group can't do that. We have periodic meetings to discuss gallery business—deciding how much to spend on promotion, considering new art work. All decisions must be unanimous.

There were eight of us; so at first we physically divided the wall space into square feet per artist. We have relaxed this. When we have a visiting or featured artist, we give that work one wall and crowd our own work together. We also take in consignment artists now.

We are now more concerned about how the gallery looks as a whole than as separate artists.

What have been your biggest problems?
Williamson: Personality problems. But we vent our feelings at

our meetings and the problems resolve themselves. We are basi
cally all friends.

It is a lot of compromising. If you go in with a selfish attitude,
you can't make it. It's like a marriage—you learn to cope, to
compromise. You must have a sense of humor. The most impor-
tant thing is being honest with yourself and each other.

Money is very important. Now we can see why gallery owners
stress the importance of selling work. After the first year we
started assessing ourselves $50 per month. Most of this goes to
promotion.

McFarland: When we started out, we had a press party and a
grand opening that was a New Year's Eve party. We started
taking very small ads in the newspapers to keep our name in
front of the public. We worked with Historic Denver to promote
the gallery. We have tried to do things that were just a little bit
different. We've taken shows from the gallery around the state
and we give workshops for different organizations.

I think the biggest drawback is that we are trying to be produc-
ing artists and we have to put so much time into being business
people.

How do you feel about the gallery now?
Williamson: It has certainly met our expectations. The pleasure
that people get from coming into this gallery is the icing on the
cake. The only frustration is that it dilutes our own time for
producing.

Going into our third year we notice things are improving. We
sell well at receptions. We sell a lot outside the gallery because
of the contacts we make here and the shows we have through the
gallery in other places.

You shouldn't go into this with the idea that you are going to
make money right away. We have heard that most galleries take
three to five years just to begin to break even.

McFarland: You have to want to do it and be willing to give up
something. You often have to think of the gallery before your
own career.

In Summary

In order to deal successfully with a gallery, the artist must understand what running a gallery entails. The first aspect that you must look at is the financing of the gallery. Every gallery has basic costs to meet—rent, utilities, licenses and permits, gallery fixtures and employees' salaries. After this there must be money for promotion—brochures and invitations, postage, receptions, advertising in the media, etc. The expenses must be met every month, whether the gallery sells any work or not. Generally galleries sell very little at first. Rarely do galleries begin to sell enough to cover expenses until their third year of existence, often not even then.

It is important to know how much capital a gallery has in order to know what you can expect the gallery to do for you. Can they afford solo exhibits with nice receptions and large mailings? Can they afford to buy advertising space in newspapers and magazines? Especially with a new gallery, you should find out about finances. A gallery that is operating on a shoestring can rarely survive for more than a few months without substantial sales.

The second major element that determines the success of a gallery is the commitment of the owner and/or director. Many people open art galleries because they think it will be a delightful, glamorous pastime. They rarely last for more than a few months. Running a gallery is hard, tedious, often discouraging work. Money alone cannot make a gallery succeed; the gallery owner must also invest large amounts of time and effort. It takes a passionate personal involvement.

These are the basic elements of every successful gallery, the things that all galleries have in common. What makes galleries different are the personality and attitudes of each gallery owner. The most obvious difference is in the taste in art. Some galleries are traditional and some are avant garde; that is just a reflection of the owner's personal preferences and taste. In some cases this taste is tempered by the salability of the art. In any event, you must understand the biases of individual galleries when selecting the one to best represent your own work.

The decor and general personality of a gallery are reflections of its owner, as are the relationships established with clients and artists. Some galleries establish a personal, even paternal, relationship with their artists, becoming closely involved in the social and emotional aspects of their artists' lives. Some galleries maintain more formal relationships.

It is important for you as an artist to be aware of all the activities of a gallery. Understanding how galleries operate and the unique characteristics of each gallery will have an impact on finding the right galleries for you—the ones with whom you can enjoy successful business relationships.

ONE ARTIST'S ENCOUNTERS WITH GALLERIES

I want to preface this chapter by saying that there are gallery people who are honest, conscientious, and sensitive to art and artists—but there are not many. If you are a new artist and you are looking for these special art dealers, you must be energetic, persistent, and resilient.

This chapter relates some of my encounters with galleries as a professional artist. The problems I have had were as much due to my naivete as to the self-concern of gallery owners. Most artists I know have their share of stories about how the artist has been maligned and mistreated by the gallery. There are dishonest art dealers, but most of the problems are not caused by dishonesty. They are the result of poor communication between artist and gallery, unrealistic expectations by artist or gallery, and simple human frailties.

The First Show

Picture a young, newly divorced woman who gave up the social and financial security as a doctor's wife in a small, isolated town in South Dakota. I was 27, a divorcee, author, and illustrator, back in my home town of Denver, determined to be a professional gallery artist. It was a time of personal doubt and confusion. I had left behind me the goals and attitudes that had been the foundations of my whole life. The only thing I knew for certain was that I was going to be a professional artist.

I enrolled in art classes and attended evening drawing sessions, at the same time working as a freelance writer and illustrator, consultant on children's literature, and preschool teacher. I

had the first exhibit of a large number of my drawings and paintings at a local community center. As a result of this show I was introduced to Pawel Kontny, a successful European artist who lived in Denver and accepted, without payment, a few students whom he believed showed promise.

When he first saw my work, Pawel thought perhaps I should return to my doctor husband. But he did accept me as a student and he was surprised at how quickly my work assumed a strength and character of its own. Within weeks he invited me to take part in an exhibit of his students' work in a prestigious Denver gallery.

There were twelve "students," young to elderly artists, in whose work Pawel had taken an active interest. Some of the artists had never shown work publicly before. Others had had wide exposure. None of us had much to do with the planning of the show; that was all handled by Pawel and the gallery owner. My own involvement was limited to producing artwork and contributing $50 toward the printing of the invitations. I allowed Pawel to select my work and even to choose mats and frames; the gallery owner set my prices.

Trembling with anxiety, I entered the gallery for the opening of the show. The smiling gallery owner walked quickly toward me, his hand outstretched. Shaking hands, I said, "Hi. I'm Carole Katchen, one of the artists." He quickly removed his hand from mine, grunted, and walked away, looking for someone more important to be gracious to. The reception was jammed with people, drinking, eating, gossiping with friends, occasionally looking at the work. The only ones who seemed to be interested in my work were two prune-faced housewives discussing one of my paintings; one was saying to the other, "How could anyone want *that* hanging in their living room?" By the end of the evening I was near despair. Sales were excellent—except for mine. I hadn't sold a thing. I felt like the whole world had come to this show and had deliberately rejected my work.

I still feel a letdown after the opening of an art exhibit, but none is ever as intense as that first one. To be rejected by an art-buying audience and to take the rejection so personally was horrible. There was a party for the artists after the reception. I

went and talked, ate, and smiled through the evening; then I went home and cried like it was the end of the world. As bad as I felt, though, I never once considered giving up my plans to be an artist and within a few days I was back at my drawing sessions trying to figure out the next step in my career.

The following exhibit, also arranged by Pawel Kontny, was a two-artist show at a smaller gallery. I shared the exhibit with a young sculptor named Ron Chapel. The reception was sparsely attended and the gallery owner led the few viewers away from our work to show them his own sculptures in the back.

The Big Break

After that show I spent four months hitchhiking and painting in Europe and Africa. When I returned, I heard from Pawel that the dealer who had staged the group exhibit of Pawel's students was interested in showing my works.

Pawel had been a great help; he taught me how to see and analyze my own work better and to arrange exhibits, but I felt it was time for me to assume more control over my own career. By all accounts this art dealer was an important man. He had dominated the Denver art community for years, and had connections in New York and Europe. He was said to be able to sell a blank sheet of paper. I was terrified to talk with the man, but I knew it was important to meet him to discuss my prospects for a show in his gallery.

Pawel said he would arrange the meeting in his own home. For weeks I waited, with Pawel explaining, the man is busy, he's out of town, he's working on another show. I decided to try to expedite things, figuring that if I had some publicity lined up for the show, it might make the gallery owner more interested.

I went to the editor of *The Denver Post* Sunday magazine, and asked if he would be interested in an article about my trip to Africa, including reproductions of some of my work from that trip. After the magazine accepted my story, the gallery owner suddenly became available to talk with me.

He told me that he couldn't give me a major exhibit because his main gallery was booked up well in advance, but he would

give me some space in his other gallery. If this exhibit went well, he would give me a show with a reception and large mailing later in his bigger gallery.

I asked him for a specific date for this show and he said he'd have it when the magazine story came out. So I went back to the editor, who said he'd publish the article when the gallery decided to have the show. I was in a quandary—I was promised a show, albeit small, and a published magazine story, but no one was willing to set a date. I had visions of years passing while I waited for them to make a decision. Afraid to offend either one by demanding a decision, I shuffled back and forth for several frantic weeks.

At last the show was hung and on the opening day, Denver had one of the worst snowstorms of the year.

Despite the snow and the lack of a formal reception, the show sold well. The dealer said he would definitely like to have a major exhibit for me. Impressed with a series of woodblock prints I had begun, he offered to advance me money on these prints so that I could work uninterrupted until the show.

From the beginning there were problems with this arrangement. The dealer started out by giving me limitations on the size of my prints and advice on the subject matter. He rejected one piece entirely, a study of a dancer, because he didn't like the knees. He told me I would have to start painting in oils; he couldn't charge enough for prints and drawings. And he told me I was getting too fat.

I wanted that show very much and I wanted the dealer to like me and my work. He was a man who could help my career a great deal. Besides this I was basically a shy person; I had a horror of public confrontations and I cried at the least rejection. So week after week I took this man my prints and listened in silence to his arbitrary pronouncements. All the time, though, I was getting more and more angry at the unfairness of the situation. Unable to argue with him, I just stopped showing him my work. Finally I decided that no matter how good it would be for my career to have a major exhibit in this gallery, I could not work with the man. In an explosive scene, I returned his money and left to look for another gallery.

Gallery Hunting

I went to a fairly new gallery with photographs of my work. The gallery director didn't want to handle my things; she said they didn't fit in with the southwestern image of the gallery. At that point the owner walked in. He was very impressed with the pictures and asked me to bring in some actual pieces of work. I showed up for the appointment with a car full of paintings. The owner wasn't there; the director shrugged and said, "It's his birthday."

Then, I went to a more contemporary gallery where the owner looked at my work, all figurative, and said, "Why don't you do some large, nonobjective canvases? We could use some of those."

Thinking I should try some galleries in an area other than Denver, I decided to approach galleries in the Taos-Santa Fe area of New Mexico. I wrote in advance to a contemporary gallery in Santa Fe mentioning a prominent dealer in Denver who had suggested this gallery for my work. In the letter I mentioned the date I'd be there and asked if it would be a convenient time for an appointment with the gallery owner. Since I didn't receive a reply, I assumed the appointment was set. When I arrived in Santa Fe, the woman said, "Oh, I've been meaning to write you not to come; we only handle New Mexico artists now."

On the way back to Denver I stopped in Taos, where an artist friend suggested I check out a new gallery that was contemporary in its layout, but showed a lot of representational work. The owners, I was told, were an artist and his wife, young and friendly. The artist's wife was in the gallery; she liked my photographs and asked me to show her the framed work I had with me. As I lined the pieces up along the wall, she picked out several she wanted to hang in the gallery. Needless to say, I was delighted.

Then the husband came in. "Hmph!" he grunted. "You know what's wrong with these? There's no emotion in them. It's not enough to be facile; you have to put more of yourself into your work."

I was stunned. I hadn't come for a critique—I was looking for a gallery to handle and sell my work. Oblivious of my feelings, he degraded my work—style, content, technique—he didn't leave anything untouched. At first I was amazed, then frustrated, then angry, and as I felt the first tears run down my cheeks, I said to him, "I don't think I want my work hanging in your gallery."

A Gallery in the Mountains

Back in Denver I was getting desperate. I had six months until a feature about my work was going to appear in *American Artist* magazine. I wanted very much to have an exhibit to coincide with the magazine article, but no gallery wanted my work. Then an artist friend told me that the owners of his gallery were interested in showing my work. It was a large, comfortable gallery in the mountains about forty-five minutes west of Denver. I was worried about the location—it seemed a little remote, but the gallery itself was a beautiful space and the owners were enthusiastic about my work. They were charming people, open, friendly, and excited about art and their gallery.

We began to make arrangements for the exhibit and I thought, *finally I have found my gallery.* They were generous about splitting the costs of a beautiful full-color invitation and of national and local magazine ads. They didn't censor or criticize my work. The one disappointment was that the show didn't sell as well as we'd hoped. But both the dealers and I were confident that sales would improve with time.

I had been with the gallery for about a year when I began to notice some negative changes in the gallery. There wasn't anything concrete, just small indications that the owners might not be as interested as they had been. Shows were slightly haphazard and the dealers weren't following up on possible sales. Then one Sunday afternoon in August, which should have been one of the biggest days for the gallery, I drove up to see what was going on. Neither of the owners was there. The gallery was open, but their twelve-year-old son was the only one present to greet clients, handle inquiries, and make sales. I decided then that the

gallery was no longer a good place for my work.

By this time I was beginning to wonder if I wanted to continue dealing with galleries at all. I was selling well enough out of my studio that I had been able to quit all of my part-time jobs, but also realized that the selling was taking more and more time away from my painting time. For this important reason I knew I needed art dealers, in order to continue being an artist. So I kept looking.

Current Affiliations

On a vacation in New Mexico I stopped in a Taos gallery to see a friend's work. On learning that I was an artist, the owners said they would like to see my work. I didn't have anything with me, but promised to send some reproductions from Denver. No longer optimistic about art dealers, I sent some photos and was surprised that these people liked the pictures and wanted to see some actual work. When I passed through Taos again, they chose several pieces that they wanted to hang in the gallery.

They were Jackson and Carolyn Hensley of The Gallery of the Southwest. Jackson, also an artist, opened the gallery because he didn't like the way other dealers treated artists. Consequently, he is sympathetic to the needs of artists. Even though his own painting is very different from mine, he has a profound understanding of my work. Carolyn, who does most of the actual work in the gallery, enjoys being involved with art and dealing with art buyers.

I have since become affiliated with a gallery in Denver as well, The Jasper Gallery (see Chapter 9). Before opening the gallery, Paige Reichbart called to say she had heard about my work and that she'd like to see it and talk with me about the possibility of showing with her gallery. I was impressed with Paige and the planning she had done for the gallery.

The main limitation of The Jasper is its size—it is very small; they don't have enough space to show much work by their artists. However, they have done a great job promoting the gallery and the individual artists. I have found that there are advantages and disadvantages to every gallery association, and it is impor-

tant to consider these carefully before making a commitment. Just as the work is a reflection of the gallery owner, the gallery casts a reflection on the art.

At this moment these are my gallery affiliations. I say "at this moment" because I have learned that a relationship with a gallery is just as tenuous as a relationship with another person. The initial problem is communication—it is important that the artist and the gallery understand what the other wants and is willing to give. After that there is the problem of the artist and/or the gallery changing its focus, attitude, or style. The Jasper, for example, might decide to turn away from representational work and show only nonobjective things, or they might include new artists whose work is incompatible with mine. Galleries can change in an infinite number of ways.

Another element I have had to consider is the scope of my career. Up to this point I have wanted to deal with galleries that were within easy driving distance so that personal communication would be easy, but I think it is important for an artist to have wide national exposure. Therefore, I have visited galleries throughout the United States and continue to do so. In addition, I carefully study gallery promotion in national magazines, and I talk with artists who show outside of my own area. Slowly I am choosing those galleries I want to approach in California, Arizona, Chicago, and New York.

Learning from Experience

The encounters I have related here are only a part of my total contacts with galleries. They have often been frustrating and intimidating experiences, but even the worst of them have helped me. One important thing I have gained is a more professional attitude toward myself and my career; I no longer burst into tears whenever my work is rejected. Being a professional artist means facing rejection almost every day by galleries, collectors, and newspaper and magazine people. I have learned that this is not personal rejection.

Also I have learned that it is helpful to know and talk with many gallery people because they are an important resource for

the artist as well as the collector. They have knowledge about art and the art business that can help any artist planning a career. Even though I have a gallery I am happy with, I continue to introduce myself to other dealers in the area, so that I can learn from them.

Perhaps the most important change in my relationships with galleries is that now when I approach a gallery, I am not only offering my work to them, but I am also judging that gallery. I can now decide whether this art dealer and this space are compatible with my work and career goals. I have the option and the responsibility to myself to reject any gallery that does not meet my standards. Most importantly, I have learned that a successful relationship between an artist and a gallery must be based on mutual respect and mutual goals.

CHAPTER 11

FINDING THE RIGHT GALLERY FOR YOU

What do you want from a gallery—a good exhibition space, an art dealer who will sell your work, exposure, promotion? A gallery can and should do many things for an artist, and before approaching galleries, you should decide what you want a gallery to do for you. If you haven't had any experience with galleries, talk with artists who have and visit galleries as an observer. After you have a definite idea of what you want, then you can start looking for a gallery for your work.

Finding the Right Gallery

As I indicated in the previous chapters, galleries differ as much as artists. A gallery that is great for another artist may be horrible for you, so it is important to shop around for the right gallery. Before approaching any gallery about handling your work, you should visit as many as possible, always asking yourself, how would my work fit in here?

Here are a few things to look for when you tour galleries:

1. *Physical qualities:* Is the space large enough and well-designed? Is each piece of work displayed clearly and prominently? Can you walk around the gallery easily? Is the lighting adequate; is each piece of work easy to see? Is the gallery clean and orderly? Are you comfortable with the decor? Do the furnishings enhance or detract from the art? Is the location attractive and convenient?

2. *Artwork:* Is the work compatible in style and subject with your own? Is the quality consistently high?

3. *Gallery personnel:* Does someone greet you and offer assistance when you enter the gallery? Are the salespeople knowledgeable about the artists and the work, including technique? Is the general atmosphere friendly and enthusiastic?

4. *Promotion:* Is there typed and/or published material about the artists on display in the gallery?

After you have found one or more galleries that seem as though they might work for you, do some additional research. Talk with artists that show or have shown with the gallery you are interested in, and ask them to describe their dealings with the gallery staff. Do they sell much art? Do they pay promptly? Do they promote their artists? Do they promote some artists more than others? If the artist is no longer with the gallery, ask why he or she left. Talk with art collectors, and ask how they feel about visiting this gallery. Do they trust the dealer?

Study local and national publications to see what kind of promotion the gallery does. Do they get listings in the gallery guides? Do their artists get reviews from major critics? Do they buy advertisements for their artists? Does the gallery participate in community activities, charity functions, traveling exhibits, museum activities, workshops, and classes?

If you still feel that the gallery might be a good one for you, call and make an appointment to talk with the gallery director. Be punctual for your appointment, dress in a businesslike way, and carry a comprehensive portfolio including many photos of your work. Bring with you one or two pieces of easily transportable work—if your work is large or awkward to carry, do not take any actual work with you.

Let the art dealer look through your presentation at his or her own speed. Do not interrupt or explain except to answer a direct question. Do not fidget, but try to look as calm and relaxed as possible. After the dealer has finished looking at the work, he or she will usually comment on it. If not, ask: Would you like to exhibit my work or do you think my work would fit into your gallery? Do not ask: Do you like my work or is my work any good? You are not there for a critique; you are there to find a gallery.

Even if the dealer is interested in your work, do not start celebrating yet; it is essential to find out the specific details of gallery policy. You might discover that the gallery has inflexible policies that you feel are unsatisfactory for your needs. It is best to check out gallery policies before committing yourself to a relationship. Here is a list of questions to help you:

1. How long has the gallery been in business?

2. If it is a new gallery, how is it financed?

3. Who owns the gallery? Is it the same person as the gallery director? What experience does the gallery director have?

4. Does the gallery operate on a consignment or direct sales basis? (Consignment means that the artist is paid a percentage when a piece is sold by the gallery. Direct sales means that the gallery buys the work outright from the artist.) If the gallery operates on consignment, how large a percentage does the gallery take? How soon after a sale do they pay the artist? Will the gallery finance time-payment sales to collectors?

5. Does the gallery give its artists solo exhibitions and/or regular exhibition space? In one-artist exhibits, who pays for the invitations, mailing, reception, and promotion? How often can an artist expect a solo or group show including his or her work? How many pieces of the artist's work will be on display at other times?

6. Will the gallery pay for promotion of the artist's work in regional and national publications?

7. Does the gallery reserve the right to select or censor the work that it displays?

8. Will the gallery accept the artist's prices without change? Does the gallery give discounts to customers?

9. If the gallery is not in the same area as the artist, who will pay for shipping? (Generally, the artist pays for shipping to the gallery and the gallery pays for return.)

10. Will the gallery insure the work against loss or damage while

it is in the gallery's possession?

11. Does the gallery insist on an agreement of "exclusivity"—that the artist cannot sell any work except through the gallery in a given area?

If the gallery's policies are acceptable to you or if you can work out a fair compromise on points that are not agreeable, the next step is to show the art dealer your actual paintings or sculptures. The best place to do that is in your own studio. Carrying a lot of work into the gallery for viewing is generally an awkward experience for the artist and the dealer. You should have your work displayed in as attractive and professional a way as possible. At this point it might be good to explain to the dealer unusual aspects of subject-matter or technique. Try to help the dealer understand what you are doing in your art and why.

Now if the art dealer says he or she wants to handle your work, you can celebrate.

Some galleries have formal contracts with their artists; others operate on a handshake. If your gallery has a written contract, study it very carefully before you sign it. If you are unsure of the implications of the contract, consult a good attorney, preferably one with some experience in the arts.

Whether a gallery has a contract or not, for my work I insist on a signed receipt that stipulates the conditions most important to me. The general form of my receipt is reproduced below:

Name of artist _____ Date _____

Address _____

Phone _____

Title of work Medium Size Price

The above-designated artworks are received with the agreement that they will be sold only at the listed price; within two weeks of a sale the artist will receive __% of that price

and the name and address of the purchaser; and until sale or
return of the works, their value will be fully insured against
loss or damage by the receiver.

Received by _____

Signature of gallery director _____

Name of gallery _____

Ramon Kelley Discusses Galleries

Ramon Kelley's paintings have been seen in invitational mu-
seum exhibits, major juried shows, and galleries throughout the
United States. He is often approached by young artists asking
how to get into a gallery. Ramon tells them to start out the way
he did, showing in sidewalk exhibits, displaying their work
wherever and however they can, and, above all, taking their
time about getting into a gallery.

"Most young painters want to get into a big gallery right
away," Ramon says. "You can't do it. You have to start out at
the bottom. Keep your eye on the papers; find the local sidewalk
shows. That's where I started. You'd be amazed at how many
people buy art at sidewalk shows.

"Then you graduate from sidewalk shows to bank shows, not
the big banks, the little neighborhood banks that are happy to
show your work. But you still haven't served your apprentice-
ship. After that, you hang your work in the smaller galleries,
maybe galleries in small towns.

"By that time the artist has formed his direction as far as
knowing how to paint and what to paint. The longer it takes to
get into a recognized gallery, the better it is for the artist to
become a great painter."

Ramon warns that if you push your career too fast, you can
lose the time that you need learning to paint. Once you are in
galleries that are successfully selling your work, there is so
much pressure to be producing salable work that you can lose

your creativity. This danger is especially great for artists who haven't built the basic skills for their art or developed their own vision before showing in a major gallery.

"When your work is getting better, you don't want to carry your work under your arm and beg for a showing. Just wait. If your work is good enough and has generated enough excitement in one area, the galleries will come to you. The first thing is learn to paint. After that everything will come in bunches."

This does not mean that if you stay in your studio painting and hide your work in the closet that someone will discover you. Ramon says that you have to get out and show your work wherever you can. Enter local and national juried shows. Sell your paintings as cheaply as you can—whatever you can do to get your work and your name known.

When you are considering going with a gallery, Ramon says you have to "do your homework" on that gallery. There are several things that he looks at in a gallery:

"Finances. Are they rich or poor? If they suffer, you'll suffer with them. If they are new and don't know anything about art, don't go with them—again, you'll suffer with them.

"The quality of work. Is it as good as yours or better? Is the gallery half-filled with cheap jewelry and knickknacks? You have to be a professional and it has to be a professional gallery, not a gift shop.

"The commission. Make sure that you are not paying a higher commission than other artists in the gallery.

"Reputation. Talk to an artist who is showing with the gallery or has shown there. Do they pay their artists? Are they easy to get along with?"

There are specific problems that you have to deal with when you have a one-artist exhibit with a gallery. Ramon explains, "If the gallery is taking 40% to 50% commission, that is enough to cover brochures, mailing, and the opening party. This should be cleared up before you start painting for the show. You are tying your time up for six months to a year and a half and you are paying for the frames.

"You have to establish when and how you are going to get paid. If a piece is sold on time-payments, will the gallery carry

the credit? Most good galleries pay you right after the show is over.

"What kind of invitation or brochure will you have? You'll have a more successful show, and you'll sell better if you put out a good, full-color brochure. The gallery should talk with the local papers about press coverage on their own, but it's good to mention it to them and to ask who they will be contacting for free publicity. I always ask for a nice ad in one of the national magazines, too. Promotion is important for the gallery as well as the artist."

Let Friends Help You Make Gallery Connections

One of the most common ways for an artist to find out about and make contact with a new gallery is through friends. Often another artist will mention a gallery that he or she is happy with, or a collector or even another gallery owner will recommend a gallery.

If you follow up on this kind of recommendation, be sure to mention the person who recommended the gallery. Generally, knowing about the recommendation will make the director more interested in you and your work.

If possible, have your friend provide you with an introduction to the gallery director—a letter if the gallery is out of town, or a phone call to say who you are and that this person has suggested you contact the gallery. I have read that it is almost impossible to get even a viewing of your work by any major New York gallery without a personal recommendation. In most other places an introduction is not that important, but it can make your approach to the gallery simpler and smoother.

In the art business, like any other business, friendship is an important commodity. I often send collectors to artists whose work I think they will like or to galleries other than my own, and most artists and galleries do the same. However, all of us are more likely to recommend the work of a friend or close acquaintance rather than the work of someone we don't know or like. What this means is that it is well worth your time to become acquainted with the other members of your art community.

Friendship is a subtle and delicate thing; you cannot force someone to be your friend just because you think he or she might be able to do you some good. As you develop acquaintances in the art community, you are bound to find some artists and dealers whose point of view is similar to yours, and friendships will develop naturally.

Maintaining a Successful Relationship with Your Gallery

As I said earlier, galleries change. So it is very important to stay in close contact with your gallery; communication between gallery and artist is essential. By visiting and talking with your gallery, you can determine whether they are meeting their responsibilities toward you. At the same time, you have certain obligations toward the gallery. Following are three suggestions for working successfully with a gallery:

1. *Visit or send a responsible friend to see the gallery regularly.* Are they displaying your work well? Are they promoting your work as agreed? Is your work all accounted for; is work missing that they have sold and not told you about? Does the gallery look prosperous or are there indications that it might fold? I had some prints in a gallery that was owned by a large group of art patrons and managed by a hired director. Whenever I visited the gallery, the director promised me that a particular collector was coming in that afternoon to buy several of my prints. No one ever did. Finally I got suspicious of the man's stories and took my work back. I felt that if he was not trustworthy in one regard, he might be dishonest in others. Some time later the director disappeared, stealing several paintings and leaving financial chaos behind him.

2. *Talk with the gallery director regularly.* Ask questions about the gallery and be honest about your feelings. If the gallery is doing something that disturbs you, discuss it. If you bring it out into the open at once, you can deal with the problem before it blows up into a full-scale disaster. I know an artist who was with a gallery for years waiting for the director to offer him a one-man show. Finally the artist told the director that he wanted an ex-

hibit. The gallery director was delighted—all this time he had thought the artist didn't want a show.

3. *Meet your own responsibilities.* Give the gallery good, new, and professionally finished work regularly. Keep accurate records of the work you give them. Make the director aware of what you are doing in your art—in terms of new subjects or techniques, or new directions in style. Inform the gallery of any new credentials you acquire. Do whatever you can to help with promotion. Encourage collectors to visit and buy from the gallery. The gallery will try harder to help you if they know that you are working to help them.

Keeping Your Own Perspective

One of the greatest dangers in dealing with galleries, especially for beginning artists, is in letting the gallery have too much influence on your career. There are some gallery directors who are openly aggressive about telling their artists what and how to paint. These dealers are hard to cope with, but at least you know that they are trying to influence your work and you can fight against that. The more dangerous dealers are those who never openly tell you what to do, but who use subtle pressures to encourage you to paint or sculpt what will sell.

Their biggest weapon is praise, effusive praise. They won't criticize the work they don't like, and they won't ever come right out and tell you to paint what will sell. They simply rave, often sincerely, about the pieces they like—i.e., the pieces that will sell—and it is hard to resist that kind of praise. If you are not careful, you eventually find yourself creating more and more of the kind of work they like, whether it's the kind you like or not.

I cannot stress enough how important it is for the artist to maintain his or her integrity regarding the creation of work. Some subjects or styles really do sell better than others and if you produce one of those, there is a great temptation to repeat the successful piece. However, once you begin to paint for your gallery rather than yourself, or to paint what will sell rather than what is the best art you can create, you are jeopardizing your entire future as an artist. Artistic vision is extremely fragile. If

you ever compromise your own personal vision, you lose something that can never be regained.

Besides subject and style, there are other areas in which dealers have tried to influence my career, primarily in pricing and framing. I carefully consider what are the most effective frames for my prints and paintings and what are the most reasonable prices. I always listen to what the dealer has to say, but I insist on making my own decisions.

Every artist must plan his or her own career. No one else can really understand what it is that the artist is working for. Sometimes an art dealer can offer useful advice, but the artist must make the final decisions.

A Gallery Exhibit

Having an exhibit with a gallery is much the same as any exhibit except that the gallery should relieve you of most of your responsibilities other than creating the artwork. In order to keep things as simple as possible, arrange all of the details when you first agree to the show. Be sure that everything is clear—date, commission, amount of work to be exhibited, who will pay for what, etc. Stay in close contact with the gallery about the design, printing, and mailing of invitations, promotion, and hanging of the show. Have all of your work finished and ready for display on time.

Pulling Out of a Bad Relationship

What if you have a serious problem with a gallery that cannot be resolved? These problems can be personality conflicts, poor sales, or bad presentation of work. Any of these reasons, if they are impeding your career or disturbing your production of artwork, are valid for pulling out of a gallery.

If possible, explain to the gallery director why you are ending the relationship. But whether you discuss your reasons or not, remove your work from the gallery as smoothly and graciously as possible. Brawling with gallery directors is not a good way to build a reputation as a serious, professional artist.

CHAPTER 12

SEMI-PROFESSIONAL GALLERIES AND OTHER EXHIBITIONS

For the artist who does not feel ready to deal with galleries and for the artist who chooses not to deal with professional galleries, there are alternatives. Many business or community establishments exhibit art on a semi-professional basis, providing free space or space for a small fee or commission. Sometimes they provide an opening reception or some basic promotion, but usually the exhibit is run in an informal way. Exhibition spaces include community centers, banks, churches, restaurants and bars, hospitals, professional offices, and shopping centers.

In this type of exhibit, there are advantages for the artist. Generally, the art in these public places gets wider exposure than in galleries because large numbers of people visit them for reasons other than looking at art. There is less pressure in regard to sales; the community center or bank has other sources of income and does not need additional income from the sale of art. Often they take no commission on sales or a much lower commission than galleries. Also, these institutions are often more flexible about the kind of work they show, and they don't usually demand impressive credentials.

On the other hand, the exhibition space is often inferior to professional galleries; you might have to hang your paintings behind potted plants or beside flashing neon beer signs. Because these institutions are not concerned about sales, they don't do much promotion of exhibits and don't provide salespeople to encourage viewers to purchase artwork. The work that does sell is usually in a lower price range than in galleries.

In order to give you some idea of how these shows are set up, I interviewed two people who run art programs in public institu-

tions. I asked them how the work is chosen and how the exhibits are organized. You will notice that these two institutions, a restaurant and a community art center, differ widely in their exhibit policies.

Restaurant Exhibits

Zach's Ltd. is a very popular restaurant and bar in central Denver. Its clientele ranges from young students to middle-aged executives to elderly tourists. It has provided exhibition space for artists ever since it opened two years ago. Ed Joseph is a bartender and the art director. He books the artists, handles the receptions, supervises the hanging, and arranges for basic promotion. The restaurant pays him a small fee for this work and he collects a 20% commission on sales. The restaurant takes no commission. Here's what Ed Joseph has to say:

"Art adds to the general atmosphere of the restaurant. It decorates the place, and the better the place looks, the more people are going to want to come into it. That's the reason the restaurant likes the exhibits. I feel that we are performing a service for artists in providing a place for them to exhibit their work.

"Artists find out about showing here by word of mouth or from being in the restaurant. Then they contact me. I like to see actual paintings rather than photos of the work, and I prefer that they make an appointment to see me rather than just dragging a bunch of paintings into the restaurant.

"I book the shows two months in advance. I like to keep the work fresh. In a year I might not like the same work.

"I look for art with emotional content. I am fascinated with human feelings or human situations rather than old mine shacks or winter landscapes. I have more latitude in what I choose because we don't have to worry about sales. The restaurant does want to stay away from nudes or anything explicitly pornographic.

"I don't look for credentials. A lot of our artists have had no formal training; 35–40% have never exhibited before.

"We have two areas where the work is hung, the balcony, which is generally for photographs, and downstairs for paint-

ings. We require twenty to twenty-five paintings. The artist hangs the work. I set the lights. We have track lights so that every painting is visible.

"The artist signs an insurance waiver. Nothing has ever been stolen or damaged.

"The restaurant provides wine for the reception. The artist handles invitations. I try to get listings in the newspapers. Art critics are a little hesitant to review work on restaurant walls.

"The main benefit of exhibiting in our restaurant is exposure. The art hangs for two weeks. In that time 20–30,000 people come into the restaurant. Some artists have made gallery connections because of shows here; others have gotten portrait commissions.

"Sales vary. The owners themselves have purchased several pieces. The paintings that sell best are priced between $75 and $300. The last artist sold nine paintings and walked away with $1500."

Showing in an Art Center

Foothills Art Center is housed in a 100-year-old stone building in Golden, Colorado. The center includes several galleries where art is hung regularly, a theater for dramatic or musical presentations, and rooms for classes and workshops. Marian Metsopoulos has been the center's director since it opened eleven years ago. She explained:

"Our primary purpose is to provide artists with a place to show their work and to provide a place where the public can see artwork. We encourage schools to bring their students; we invite old folks' homes to visit. We have music programs, poetry readings, Weight Watchers' meetings, and lots of classes—all the people who come for these things also see the art. We are trying to be a full community art center.

"In our exhibits we hope to make some money, but that's not our primary goal. We have other ways of supporting ourselves. We are not well-known for selling. We haven't got the money for advertising. But we are growing.

"We have three kinds of exhibits: one-person shows, mem-

bership shows, and open competitions in specific media.

"We have 35–40 one-artist exhibits a year. Any artist can apply for a show. The exhibits are awarded by our Exhibit Selection Jury, a changing committee of ten artists. Selection is based on quality and originality of work. We ask for a resume, but that has a minor influence on the decision. We schedule our shows a year in advance. An artist who is rejected by the committee can re-submit later.

"Since we have several galleries, we can schedule a number of exhibits at the same time. We change the exhibits simultaneously once a month and have a reception for all the new artists. We request $10 from each exhibitor to contribute to the cost of the reception and the printed matter. The announcements of new shows are sent to those on our mailing list, approximately 800, and each exhibiting artist gets 25 additional flyers for his or her use.

"It is the artist's responsibility to hang his or her show and to take it down. We will provide help if requested. Our insurance covers the work while it is on the premises—$50 deductible in case of fire, theft, or vandalism.

"These are professional shows. Someone is always present to handle sales. We rarely sell paintings for more than $300. We take a 25% commission on sales by members of the center and $33^{1}/3\%$ from non-members. We keep a resume on file of every exhibiting artist. We get some radio and newspaper coverage. We now have a professional public relations director working part-time."

Sidewalk Shows

John Eyer is a retired electrical engineer. About twelve years ago he decided he wanted more in life than just watching television; so he started taking adult education classes in drawing and painting. He now works full-time as an artist, painting and studying art. He is a member of two local art guilds and regularly shows his work in guild exhibits at community centers, banks, and hospitals. He also shows his work at various sidewalk shows, which are two-to-three-day shows set up by an organiza-

tion in a large, open space such as a shopping center and are generally open to any artist who cares to exhibit. Each artist pays a fee for a space and sets up his or her own show. The artist sits with the exhibit throughout the show and handles his or her own sales.

Last year John grossed $3,000 from his art. "I wouldn't want to paint and not sell my work," he says. "I don't have to make a living from it, but I make enough so that we can take the trips we like. If people are willing to give me $100 for a painting, I know they like it."

John Eyer discusses sidewalk shows:

"First you have to decide which ones to enter. I look for a location where there will be a lot of people. The more exposure you get, the more likely you are to sell. I prefer an inside to an outside show; you don't have to worry so much about the weather. Some neighborhoods are better than others. The best seem to be those with young families, with new homes or a lot of apartments. Usually it's the young couples who buy the pictures.

"Usually there is a small entry fee, $3–$15. Sometimes the center takes a small commission to cover expenses.

"You have to set up your own stand. I use simple, A-frame stands made of pegboard. They have to be sturdy so that they won't blow over outside. Most shows give you a display space of 8' × 10' (2.4m × 3m) or 10' × 10' (3m × 3m). I do a lot of demonstrating, usually with acrylics; it creates more interest in my display. Since that takes more space, I often pay for two display spaces.

"Lights are a problem. Some centers have bad lighting at night. So when I can, I bring and set up my own lights.

"It's best to be organized about getting ready for a show. I load up everything the night before and allow at least two hours before the show for setting up. I made a cart for transporting things from the car. Some people have built carts that convert into tables.

"Sales vary. I might sell $60 in one show and $300 in another. I usually sell small, inexpensive pieces, $40–$50. Besides the

sales, the contacts you make at these shows often lead to other things.

"I use Master Charge and BankAmericard to sell on credit. A lot of people will want to buy something, but they don't have any money on them. I keep names and addresses of buyers. I have a card file arranged by zip codes and send postcards to people in the area of an upcoming show.

"It's an ego thing—to be where the people see your pictures and talk to them, to meet the people who buy your work, and to meet the other artists. Sometimes the days get long, but it's fun to watch the people."

Some Things That Can Go Wrong

Because these exhibits are not run by professional art dealers, they can have their own unique problems. During my art career I have participated in several semi-professional shows and each one brought its minor disasters.

The only outdoor show I took part in was on the sidewalk in front of a large office building in downtown Denver. It was an unseasonably cold spring day. I and the other artists sat huddled in borrowed coats and sweaters, warming up only when we jumped and ran to catch a painting that was blowing toward the street.

At an exhibit in an elementary school, the staff was worried that my figure studies were pornographic. At a group show in a restaurant, the manager took a figure painting off the wall because he thought the woman in the painting was ugly.

By far the most traumatic show I ever had was at a community center. The art director got married and left for her honeymoon the week before my show opened. The center sent out invitations, but they were mailed late and most people didn't realize that they were invitations to an art exhibit—they were small postcards with cheap printing and tiny reproductions. At the reception no one bothered to collect money for purchased paintings. During the show a clothing sale was held in the center and I walked into the gallery one day to find garments hanging all over

my paintings. One sold piece was misplaced; it was eventually found, but before it was given to the purchaser, it was dropped and the frame shattered. And I had trouble getting my money after the show.

This certainly was not a typical show, but it does point out that the artist should do research before a semi-professional exhibit as well as a gallery exhibit. It is especially good to talk with artists who have shown there before.

Above all else, to have successful semi-professional exhibits you must have a calm disposition and a great sense of humor.

How to Find Semi-Professional Galleries and Exhibits

Talk to other artists about where they have shown, and look in gallery and art show listings in the newspapers. Local art guilds often find locations for group shows for their members, and they usually are aware of upcoming sidewalk shows. Some local and regional art publications list these shows.

Keep your eyes open—when you visit your bank, your doctor's office, or your favorite restaurant, notice whether or not they exhibit artwork. If they do, they probably will be happy to talk with you about an exhibit and look at your work.

PATRONS, AGENTS, AND PRIVATE DEALERS

Again and again I have heard artists say, "If only someone would give me enough money to live on so that I could be free to paint. It's too bad there aren't any more Medicis."

Actually, for the artist who is interested in finding patronage today, there are many wealthy persons who want to take an active role in developing art. The incentive for this involvement is the same as it was 500 years ago—the sense of power that comes from helping to guide and support a developing artist. Also, there is the possibility of making money by investing in a young artist. This chapter tells about some of today's patrons and various other artists' representatives who have removed part of the financial and business management burden from the working artist. In some cases the relationships have been successful; in others, nearly disastrous.

A Guaranteed Income

Pawel Kontny first visited the United States in 1960. He was a successful European artist touring America with his family, having shown his work in major museum and gallery exhibitions throughout Germany and Switzerland as well as several U.S. cities.

When the Kontnys visited Denver they were amazed by the spaciousness of the city. With the help of friends, they found a large home with an enormous yard; it was in a quiet neighborhood on the outskirts of the city—a combination almost unheard of in Germany—and they decided to move to Colorado. Pawel put a deposit on the house and returned to Germany to organize

the move. Two years later the Kontnys immigrated to the United States.

When the Kontnys moved into their Denver home, it was with a great sense of insecurity; Pawel was an alien who spoke "not one word of English." Besides having to meet the living expenses of himself, his wife, and two small children, he was faced with the large financial obligation of the home. He had been a successful artist in Europe, but now most of his business and social connections were thousands of miles away.

It was with relief that he signed an exclusive contract with a Denver art dealer guaranteeing a monthly income of $1500. Pawel would be free to paint while the dealer handled all aspects of promotion and sales.

The terms of the contract stipulated that every month the dealer would give Pawel at least $1500. The dealer could select $1500 worth of paintings and drawings from Pawel's monthly work; the selection was at the discretion of the dealer. Pawel was not allowed to sell work except to that dealer.

"He never cheated me," Pawel says of the dealer; he always gave Pawel the monthly fee. However, the dealer rarely agreed to pay more than $150 for a painting; he bought many as low as $25, Pawel says. The artist had no bargaining power because of the exclusive clause of the contract. He either had to sell the paintings to the dealer at a low price or not sell the work at all. At an average of $75 per painting, Pawel was obligated to paint twenty acceptable pieces every month. Some months the dealer rejected everything Pawel did; then he was obligated for forty paintings the next month.

As in all direct sales agreements, once the dealer owned the work, he could sell it at whatever price he wanted. Often, Pawel's dealer would buy a pastel for $25 and resell it for $250. Pawel was not entitled to any of that profit.

After eight years the dealer finally agreed to terminate the exclusive contract. Looking back at the arrangement, Pawel says, "Never sign an exclusive contract. You are a slave; you are owned by the gallery. I blame myself. If I was so dumb, then I deserve it."

The Barter System

Blaine DeMille, a painter, explains that when he was at a dinner party one evening in 1974, he was talking about how important it is for an artist to work full-time. "It's pretty depressing to be a 30-year-old busboy just so you can pay your rent," he said.

One of the other guests at the party was a collector who was very impressed with Blaine's work; he had, in fact, just bought several of Blaine's paintings at a one-man show. The man said he owned a vacant house, and he would be willing to let Blaine live in the house in exchange for paintings.

The house was fairly old and run-down; at the time it was being used for storage. Blaine tore out old rugs, repainted the whole interior, and hauled junk out of the backyard. He and the patron agreed that one painting a month would be a fair rent.

What began as a friendly relationship quickly deteriorated into a source of anxiety for both artist and patron. "I was showing him all my current work, between five and twelve paintings at a time," Blaine says, "and he wouldn't like any of them. He felt that I was cheating him, that I was keeping the best ones and selling them behind his back.

"He would say, 'These aren't as good as the ones I bought.' Of course, they weren't. He had bought two or three of the best pieces from an entire year's work. Now he wanted me to create a masterpiece every month.

"The main problem was that it was a vague agreement to begin with and it finally became a matter of his taste against mine."

During the year Blaine got about five months behind in his "rent." Finally he and his patron had a tremendous fight and Blaine was evicted from the house.

"It made me grow up a little if nothing else. I learned that collectors of art do not always have as their concern the development of the artist. Some of them are just interested in a short-term investment. Art doesn't work that way; it takes time. I now am better able to tell what a person's motives are."

Since that time Blaine has traded paintings for other goods and services. He has paid veterinary and dentist bills with art-

work; he painted a mural in an automotive garage in exchange for repairs of his truck; and he traded paintings for a $7,000 acre of mountain property.

The Classical Patron

In the spring of 1973 a wealthy Denverite decided he was bored with retirement. An art collector for many years, he decided it would be exciting to become more involved with art by sponsoring a small number of promising young artists. He selected three sculptors and a painter, two men and two women.

The arrangement was that the patron would pay each artist a monthly fee for living expenses plus any additional working expenses for a year. During that year each artist would complete an agreed number of sculptures or paintings. At the end of that time the patron would set up exhibitions of the work in major galleries in the United States and Europe. The initial sales would be used to repay the patron's investment; after the basic expenses were repaid, any profits would be split 50–50 between the patron and the artist.

George Tate was one of the sculptors. Every month he received $550, an amount he felt was adequate for living costs. The patron paid that and George's working expenses regularly without question or complaint. For the first time since George had been a serious artist, he felt himself truly free to work.

"I have never worked as hard as I did that year," George says. "I put in ten to twelve hours a day. My roommate used to call me The Shadow because I got up at five or six o'clock to drive to the foundry every morning and I didn't get back until night.

"I got a tremendous amount of experience in an area where I never could have afforded to work on my own. There is no way I could have paid to cast such big pieces without help." George says that his patron spent about $40,000 just on casting George's work. For one of the other sculptors, he spent over $100,000.

At first the patron kept a close eye on the artists' work, wanting to see every piece. After a few months he let the artists work

independently. They were free to determine all aspects of style, size, and subject matter.

The artists were delighted with this freedom until they realized it really wasn't an indication of the patron's confidence in them; it was an indication of his loss of interest in the project.

During the course of the year the patron became very involved in personal affairs. Moreover, he began to realize the enormity of the task of promoting artists and arranging exhibitions. This was more work than he had anticipated. There was no stipulation in the contract about when the exhibits had to be arranged; so the patron let that part of his responsibility slip by.

At the end of the agreed time George found himself in a frustrating position. He had executed and cast seventeen major pieces of sculpture, but until the patron set up shows and sold enough to pay the initial expenses, George couldn't touch any of the work. It was his sculpture, but he didn't own it; he was in the same position financially that he had been in before the patronage. George still didn't have money to live and work. He had a great amount of experience working with cast bronze, but he couldn't afford to continue to work in that medium.

Three years later George is supporting himself with welded bronze sculptures. The patron still has not arranged an exhibit of George's cast sculptures. Some of the work has been sold, but not nearly enough to pay back the patron's investment and George sees no way of ransoming back his work.

Subsidized Travel

Bob Ragland has traveled to Jamaica twice with the aid of patrons. Bob explains, "I invite several of my collectors to a party. I explain that I have a painting trip in mind. I ask them to back my trip by contributing at least $75 or $100. In return for their money, they can pick out a painting or drawing from the work I bring back. They have to know your reputation and trust that you will be doing paintings that they will like."

Fritz White, a sculptor from Valley Mills, Texas, arranged a similar program with the help of the Denver Jewish Community Center. Together they enlisted a group of collectors who fi-

nanced an eight-week trip to Israel for the artist and his family. Forty-six patrons contributed about $30,000 to pay for travel expenses, casting twenty bronze sculptures, mounting a major exhibition at the Denver center, and implementing an extensive traveling exhibit.

The patrons contributed $500 or $1000 each with the understanding that they could choose any piece worth up to twice their investment from the twenty pieces of sculpture the artist promised on his return. For $500 a patron would get a sculpture worth up to $1000.

"I didn't worry about being able to do the work," the artist says. "I knew that unless I dropped dead, I would meet my obligations. And I took out a life insurance policy to cover that possibility."

The artist visited Israeli cities, villages, kibbutzim, military posts, synagogues, factories, museums, and universities, making sketches and notes of sculpture ideas. He created the promised twenty pieces (he rejected one after casting) and says he still has subject matter for twenty more.

The community center held a patron's preview party, followed by a major opening. During the show they sold $70,000 worth of sculpture, including the work that went to the original patrons. The center received one of each of the nineteen sculptures for its collection. Profits from the show were divided between the artist and the center. The center received 60 percent.

Where Do You Find a Patron?

There is no easy answer to this. All the artists I know who have developed a patronage have had close, friendly relationships with their collectors. I would suggest that you start there, with your own collectors. If you don't have personal connections with collectors who seem wealthy enough to support a patronage of some sort, ask for help from whomever you know in the art world who might have such friendships.

Before you approach anyone, decide exactly what you would like a patron to do for you—support you for a year, pay your

way on a painting trip, finance a major exhibit—and have some proposal of terms that you think would be fair and workable.

Setting Up an Agreement with a Patron

Many of the problems that can arise from patronage are obvious in the stories I have related here. The basis of most of the difficulties are loose, unclear agreements. So if you enter into a project with a patron, be sure that you have a firm, specific agreement, preferably a written contract. As with any legal contract, it is a good idea to have your own attorney study and explain it thoroughly before you sign it.

All the responsibilities of the artist and of the patron should be detailed in the contract. All specifics of time and money should be stipulated. The details regarding approval or rejection of the work are very important. Also, you should state the consequences if one or both parties do not meet their responsibilities.

Regardless of how well thought out your agreement is, there will probably be questions later or difficulties that arise. If the artist and the patron trust each other and respect each other, the problems can usually be solved without great distress. Never enter an agreement with a patron whose motives are unclear, or whom you do not trust, or whom you cannot communicate with easily.

I think that generally, short-term projects work out better than long-range schemes. If you do enter into a long-term project, make sure that the patron has the financial resources to sustain his or her obligations.

The Government as Patron

At the moment there are numerous local, state, and federal programs designed to fund art projects. In order to get specific information, contact the agencies directly. They usually are not very good about publicizing their programs, so you might have to do a lot of research to find them. The National Endowment for the Arts is now the major government patron of the arts.

Check the *Fine Arts Marketplace* or other art directories for information. As in any other patronage, be sure that you understand all aspects of the agreement before you commit yourself to any of these programs.

Agents

According to Tom Pennington, a public relations consultant who has worked as an artist's agent, "Artist's agents are as rare as hens' teeth. There are very few in the whole country. I don't know where they are or how you find them. Probably you don't find them—they find you."

The function of an artist's agent is to promote the artist and market the work. This sounds simple, but a successful artist-agent relationship is nearly impossible to maintain. Tom says the most common problem facing agents is in handling beginning artists who, as soon as they have a little success, sever the relationship. He says that the artist often begins to believe the publicity that the agent has created. The artist makes unrealistic financial demands, and expects the agent to be a travel agent, personal secretary, and therapist. "Living artists are considered to be walking trouble, too much gut-level emotion."

On the other hand, most people who try to be artist's agents do not have the necessary qualifications. Either they know a lot about art and nothing about marketing, or they know about marketing, but not art. Or they know art and marketing, but they are insensitive to the needs of the artist. Tom suggests that the artist look for these qualities in an agent:

1. *Experience.* Experience is the single most important thing to look for, at least ten to fifteen years of markcting in or near the arts.

2. *Self-assurance.* Find someone who's not afraid to go out and sell.

3. *A very high interest in art.* Half of selling art is educating the buyer.

4. *Personal trust and confidence.* "If I couldn't trust this man, I wouldn't hire him."

To create a successful relationship he says, "Work at arm's length; it's not good to be too close. Pin down all details. Have a fair price worked out ahead of time, a fixed fee—stay away from percentages as much as possible."

Private Dealers

A private dealer is one who sells art directly to collectors without an established gallery. Most private dealers only handle work by dead or nationally established artists. However, two dealers in Denver have created a firm that sells work by contemporary local artists on a private basis. They approach architects and interior designers with slide presentations of various artists' work. They establish what the designer's needs and tastes are and then find the artwork for a particular job. The disadvantage for the artist is that since it is a private negotiation, the artist does not get the public exposure that he or she would from dealing with a gallery.

Consignment vs. Direct Sales

In dealing with private artist's representatives or with galleries, the question arises as to whether it is better to work on a consignment or a direct sales basis. Many people have told me that the only way to work is through direct sales. Both artists and dealers have told me this. Though I see disadvantages to both approaches, I think artists must weigh the pros and cons and decide for themselves.

The lure of direct sales is that the artist gets paid for the work immediately. You take your work to the dealer who pays you for the work before it is even exhibited. This can be especially important to a sculptor who has high everyday working expenses.

The payment for work bought directly is usually less than on consignment. In Denver it is standard for an artist to receive

50% of the retail price for direct sales, and 60% on consignment. However, many artists would prefer to have 50% now rather than wait for 60% next week or next year or whenever the gallery sells the work. Also, artists have told me that if the gallery owns the work, they will be more concerned with selling it.

On the other hand, a dealer who can afford to buy work outright generally has enough money so that it doesn't matter when he or she sells that piece of work. The dealer can afford to store the work for a year or two, speculating that the value will increase. When the artist sells the work directly, the artist gives up all control of when, where, how, and/or if the piece is displayed. Also the artist loses all control of pricing. A dealer can price your work outrageously high or low, and you have no legal right to protest.

One particular Denver dealer had bought a large number of paintings from an artist during the time they worked together. When the artist decided to leave that gallery, the dealer was furious. He told everyone that the painter was washed up, finished as an artist, and he marked all the paintings down so low that people would think they were worthless. In order to save his reputation, the artist was forced to secretly borrow money and send someone into the gallery to buy back all his work.

COMMISSIONED WORKS

Agents and other artist's representatives often help artist's careers by setting up commissions. Of course, it is also desirable for artists to acquire commissions on their own behalf.

Besides the money, commissioned works do much to enhance an artist's reputation. The execution of a public sculpture, mural, or portrait of a prominent person almost always adds weight to an artist's credentials.

There are many sources of commissions—government grants, public institutions, corporations, and private individuals.

Some commissions are granted on the basis of competitions. Winning competitions is as unpredictable as any other contest. Often the jurors have a fairly specific idea of what they want to choose. If your entry happens to be closest to that idea and if there are no political maneuverings in favor of another competitor, you may receive the commission.

Other commissions for artwork are granted in a more direct way. The person(s) in charge of the project contact the artist(s) directly and negotiate the deal in a more personal way. Most portrait commissions are handled through direct contact with the artist or the artist's gallery.

The execution of a commissioned work involves many problems that the gallery artist might not face in his or her usual work. The artist is required to work within tighter guidelines than usual, the theme or subject originates with someone other than the artist, and the size and medium are predetermined. Often the work is larger than anything the artist has done before, and the artist must learn new technical skills, sometimes at the

expense of major artistic and/or financial difficulties. The unfinished work is often paid for or at least contracted for, so the artist feels a greater responsibility to please the patron and the patron sometimes feels a greater authority in guiding the execution of the work.

I have heard many vague stories of artists' being victimized in the execution of commissions, usually by not being paid for work completed. However, I have interviewed a number of artists who regularly execute commissions and none of them had such experiences. In fact, the general feeling was that patrons are more likely to suffer, receiving the work incomplete or late or receiving an inferior piece of work because the artist was not qualified to handle the commission.

In a recent unveiling ceremony for an official governor's portrait, the governor and guests stood by ready to applaud. The cloth was removed, revealing an empty easel. The artist just hadn't gotten around to finishing the portrait.

This is not to say that the artist should not take steps to prevent being misused. The first step is to carefully decide if the work is something you want to do and are qualified to do. For instance, do you have the technical skill to execute a monumental bronze sculpture? Secondly you must be sure that all terms of the commission are clear to you and the patron.

The terms, especially for a major work, should be carefully considered. Usually no money changes hands until an initial model of the work is approved, and at that point the artist should receive partial payment and a written guarantee of the balance on completion of the work. It should be firmly agreed that the patron has grounds for withholding payment only if (1) the finished work is not reasonably close to the approved model, (2) the work is not completed on time, or (3) the work is not technically competent. I strongly recommend a written contract.

In considering a commission, beware of hidden costs. I once considered painting a mural for a local college until I realized that renting scaffolding would cost as much as the commission paid.

Following are interviews with four artists who talk about how they handle commissioned work.

Two Artists Discuss Portrait Commissions

Wally Swank works both as a commercial artist and a gallery artist. He says, "It's hard for me to separate art into fine and commercial. Art is art. The main thing that distinguishes commercial art is that you are working to satisfy a particular client, so it is more restrictive than gallery art. In that sense, painting portraits is like commercial art. Your finished painting has to please a client."

Wally says his portraits are tighter and more controlled than his other non-commercial work, but he still likes to maintain a feeling of spontaneity. "What people want a lot of times is a painted photograph. I'd rather make it look like some kind of painting with splatters and dribbles. If they want it to look like a photograph, then they should go to a photographer's studio.

"Usually, people approach me about portraits. These people are friends or other people who have seen my portraits. If they haven't seen my portraits already, I have them come and look at my work, so that they'll know what I do. I ask if they want a watercolor or a loose oil sketch or a more formal oil. Then we come to terms on a price and set up a time for a sitting.

"I like to work from life, but kids can't hold still, so I usually paint kids from photographs. Working from life, it usually takes two or three sessions, a couple of hours each. Sometimes I paint from a photo in between sessions. I just do head or bust studies; I don't know how long it would take for a full-length portrait.

"I like to get something that's pleasing as a piece of art. Only sometimes am I satisfied with a portrait as a painting. That's what is so frustrating.

"I am more critical of the works than the person buying the portrait. Just once I had to change a portrait—the cheeks were too wide.

"I liked to paint heads before I ever thought of doing portraits. You have to like to do portraits. Don't do it just for the money. You give up an awful lot of freedom."

Doug Dawson works strictly as a gallery artist. He refuses to paint to other people's specifications; so he accepts portrait commissions only with very specific conditions. He explains:

"I don't accept a portrait commission unless the subject interests me. I don't require an initial down payment because I would be interested in painting the subject regardless of whether or not the portrait is accepted. From my point of view, I am getting a free model. I reserve the right to develop additional work from the materials gathered—for instance, other paintings from studies of the subject. I reserve the right to use my own esthetic judgment in the development of the work—pose, colors, etc. I make it clear that I do not guarantee exact likeness.

"About the only consideration I give to the patron is the size of the piece—and the fact that they are not financially obligated to buy the portrait if they don't like it. I have refused several commissions based on photographs submitted to me; the only time I would work from another person's photographs would be if the subject were deceased."

Commissioned Sculpture

Ken Bunn is a sculptor whose bronzes, primarily of wildlife, have been exhibited in the United States, Europe, and Africa. Currently he is creating a major piece commissioned by the Denver Zoo. He says that an increasing number of commissions are becoming available to the sculptor today.

"I find commissions through the National Sculpture Society, artists' newsletters, in local newspapers, or by word of mouth. In considering a commission, I decide if I have time and if there's enough money in it. I figure out what it's going to cost to cast it. Once I know the physical costs, then I estimate my time and decide if the commission pays enough.

"Some artists early in their careers are interested in the authorship of a sculpture in a public place, and they don't care about much more than covering their expenses. But you have to be careful not to lose money. Most people have no idea of what the costs are of casting sculpture.

"You can usually get a very firm price by sending a photo and the size of a piece to a foundry. That should include the mold, casting the bronze, and shipping. Add to that the expenses of making the model.

"You have to draw up an agreement with the people who are letting the commission. If they are unwilling to sign an agreement, they probably don't have confidence in you or they just want to use you for your ideas. In either case, you don't want to work with them.

"The agreement should cover: (1) Who is building the base? (2) Who is responsible for shipping and insurance? (3) Who is responsible for setting it up on the base? (4) If it is a delicate sculpture subject to vandals, who is responsible for damage due to vandalism?

"Approval of the sculpture should be based on the model. After they accept the model, they should rely on your judgment. They must have confidence in you and your work.

"I think twice before I do a little commission like a portrait. I tell them that when I have time, I would like to do an informal study. If something comes out of it that they like and that I like, then they can buy it. That way I'm not under the pressure of making something that will please them. Some people don't have any idea of my style, or they have an exact image of what they want in their head and no matter what I did, I never could please them.

"It's my gamble to do it and if it doesn't sell, I'm stuck with it. At least if I like the piece, I haven't wasted my time."

Painting for Publication

In 1972 Gene Boyer entered a painting contest sponsored by *The Saturday Evening Post.* He won second place in the national contest and has been creating illustrations for the magazine ever since. Currently he is the staff artist responsible for most of the covers.

Painting for *The Saturday Evening Post*, especially covers, involves major artistic concessions. According to Gene, the general consensus is that the cover determines 50% of newsstand sales of the magazine. Newsstand sales are best if there is a familiar face on the cover.

"You are trying to sell magazines. If the art will attract them enough to pick up the magazine, there is a good chance they will

buy it. I would like to do some nice art covers, but personalities sell the magazine.''

The executive editor generally decides whose face will go on the cover. Because of time and budget limitations, Gene is rarely able to work from life or even from his own photographs. He is given the subject and then he researches, collects, and studies whatever photographs he can find of the person.

"In the case of Jimmy Carter it had to be a formal presidential portrait. I found the expression I wanted in an informal photograph, open collar and shirt-sleeves. In going through more photos, I found that he has a favorite tie. I added that tie and the suggestion of a suit.

"I usually use photographs for establishing the basic form of the painting. I never use color photographs—you never get good color balance. I rely on my own judgment and eye for color.

"In planning my layout, I leave space for the logo and cover copy. Generally I leave a lot of space on the sides, top, and bottom so that the art director can have latitude with the final layout.

"In choosing my background color, I have to avoid repetition from month to month. I often key colors to the season of the year. I keep in mind the psychology of color; for instance, the distribution people say blue does not sell, yellow does.

"Forget about convincing anyone you are an Artist. You can't be a raving prima donna and expect to make a living in this business. There are too many people out there who are willing to compromise. There is so much talent around and so few good publishers. You have to be flexible, and to be tolerant of their needs.

"There are times when you can break or bend the rules. If you do it intelligently, you can usually get away with it. There are some pictures that I have to refuse to do for my own integrity.

"When I first started working with the *Post*, they wanted to see a rough draft of every illustration to have some idea of what to expect. Now they trust my judgment. You have to be patient about developing a relationship. They don't understand the temperament of the artist, and the artist doesn't understand the logistics of the publisher.

"With the *Post* I work on a salary basis. With other work, with people I haven't dealt with before, I ask for half in advance. Publishers usually deal ethically with artists—they know they might need you again next month.

"Regarding ownership of work, the *Post* gets the copyright, but the artist keeps the original. If a company insists on ownership of the work as well as copyright, I double the price. For a private party who is only interested in the original, I retain reproduction rights."

CHAPTER 15

ART IN
THE NEWSPAPERS

How do you get free publicity in the newspaper? Not by magic or by luck. It's a matter of approaching the right people in the right way.

The Art Editor

Most major newspapers have one person who handles all of the art news. When you have an art item that you think is newsworthy—an exhibition, an award, a public project—the art editor is the person you should contact. If the art editor thinks it is newsworthy, he or she will then either write the story or assign it to a reporter.

Call or read the newspaper to find out the name of the art editor. Then either phone the editor or go to the newspaper office in person. If you phone, identify yourself as an artist and then quickly and clearly tell why you have called. For instance, "Hello. I am Carole Katchen, a Denver artist. I am having an exhibition of paintings and graphics at The Jasper Gallery next month and I thought you would like to know about it. It is an unusual show because all of the pieces are studies of dancers."

After you answer any questions the editor has, you should add, "I will send you a press release and photo of one of the paintings this week. I would appreciate it very much if you could arrange to see the work."

And be sure to thank the person for his or her time. If you are going to be a successful artist, it is basic to establish a good relationship with the press. You begin to build this relationship by being courteous and by showing respect and appreciation for

the art editor's time and interest.

If you go to the newspaper office in person, you are taking a chance that the art editor will not be there. If he or she is not, you can either leave your material (press release and photo) with the secretary or you can return again to try to meet the person. The latter is what I usually do, returning until I see the art editor. I think it is a great advantage to establish personal contact with news people. They are usually more interested in work by people they have met and when you call them the second time, they are more likely to remember who you are.

When you go to the newspaper office, bring a press release and at least one good photograph of either your work or yourself working. (I will give suggestions for writing press releases in the next section.) Be very positive in your attitude and direct in your approach. Quickly and clearly explain why you are there and give the editor your material. Do not take more time than is necessary—art editors are notoriously overworked.

If you have previously met the art editor, mention that occasion. If someone the art editor knows has referred you to the editor, mention that person. These things will make it easier for the art editor to remember who you are.

How to Write a Press Release

A press release should be typed, double-spaced, on a white 8½″ × 11″ (22 cm × 28 cm) sheet of paper with at least one inch margins all around. Generally it should be no longer than one page.

At the top of the page type your name, address, and phone number. Begin with a paragraph that tells the most interesting information about the show or other event that you want publicized. Include the name of the artist, the date, the location, and a brief description of the event, plus any other pertinent facts about the event, opening and closing dates, times, address, etc.

Next there should be a short description of the work—subject, medium, size, number of pieces. Emphasize those aspects of the work that are the most unusual, but avoid highly technical descriptions.

Include a short biography of the artist, no more than one paragraph. Use only the most interesting and/or impressive credentials.

Finally, add a statement that you will be happy to answer any additional questions and state when the work will be available for viewing.

Following is a press release I have made up to use as an example:

Name
Address
Phone Number

Paintings and graphics of dancers by Carole Katchen will be presented at The Jasper Gallery July 28 to August 20, 1977. The gallery is located at 1329 Eighteenth Street, Denver, Colorado. Exhibition hours are Tuesday–Saturday 11:30–5:00.

This one-woman exhibition includes twenty-five acrylics, watercolors, and woodblock prints, all based on drawings of professional dancers. Ms. Katchen observed and sketched dancers in classes and rehearsals of The New Dance Theater and Colorado Concert Ballet. In order to understand the dance movements and portray them accurately, the artist has taken modern and jazz dance classes for over a year.

Carole Katchen is a Denver artist who has studied art in London and Jerusalem and has exhibited her work in the United States and South America. One of her paintings was recently selected for the 1977 Pastel Society of America exhibit in New York. Her work has been featured in *American Artist* and *Artists of the Rockies* magazines. She was chosen for listing in *Who's Who in the West*.

(If you have any questions, please call me at the above number. The show will be hung on July 27. If you would like to see the work before that time, it will be framed and available for viewing at my studio after July 21.)

Interviews with the Press

Some newspapers give critical reviews of art exhibits. Others are more interested in feature stories about the artist; generally these stories are based on an interview with the artist.

There is no way to predict what an interviewer is going to ask. Every editor and reporter has different ideas about what will be interesting to the paper's readers. So there is no way to prepare answers ahead.

You can ask the editor/interviewer what kinds of questions they will ask. This might help. Also, you should become familiar with the paper before your interview. Pick up a copy of the paper and study it for some idea of how they handle art stories.

Generally what the interviewer wants to know is who you are, and why and how you create your art. It often helps to have some of your artwork or photos of it with you so that you will have something concrete to talk about.

When you are being interviewed, be as friendly and relaxed as possible. Speak clearly, especially if the reporter is using a tape recorder. Speak slowly if he or she is taking notes by hand. Listen carefully to the reporter's questions and answer them as well as you can. If the reporter does not ask a question about something you think is important regarding your work or career, talk about it anyway.

Do not say anything that you would not want to see in print. This is very important. Many artists complain about how they have been misquoted in the paper. Often it is not a misquote at all—often the artist has just been talking loosely, forgetting that his or her words were going to be printed and read by thousands of people. There are statements that are perfectly acceptable in private conversation, but are outrageous in print. Keep this in mind during an interview. A few specific things to avoid:

1. *Do not say anything negative about your work or your career.* A year ago a feature story appeared in a Denver paper about an artist who was having a bank exhibit, but the exhibit itself was given minor attention in the story. Most of the space was devoted to the artist's complaints of what a hard time he is having because no galleries want to show his work. Readers will gener-

ally assume that an artist who is featured in the newspaper is successful—unless the artist says that isn't true.

2. *Do not say anything degrading about collectors.* Many artists like to deprecate the art-buying public. How often they say things like, ''People around here don't know anything about art; look at the junk they buy.'' Whatever you say about art buyers in private, be respectful toward them in public, and especially in print. After all, these are the people who are supporting you.

3. *Do not say anything derogatory about other artists.* Even if you think another artist is the lousiest painter who ever lived, do not say so to a reporter. Saying negative things about other artists in public is very unprofessional.

The Views of Three Art Editors

Irene Clurman, of *The Rocky Mountain News*, has worked for the Denver morning daily for five years. Her background includes a degree in art history from Stanford University and two years as a reporter for *The Gallup Independent* in Gallup, New Mexico.

What is your job as art editor?
I am the only one on the paper who writes art news. I cover art, books, and theater. I write some general features and also do the gallery listings. I write one major art story a week. If I have time to do more, the newspaper will print them, but I just don't usually have time.

I try to cover what's going on in the art world. I approach what I am doing as a reporter. I do things in a very personal way. Sometimes it boils down to opinion, but I don't think of myself as a critic. I don't write critical reviews. I do my criticism before I go to the show, in deciding what show to go to. Some people want me to tell them what they should be looking at; I would rather let them deal with that on their own.

How do you choose the artists that you write about?
I look for quality and innovation in the work. I try to cover

major shows. I am less likely to cover bank and restaurant shows, but there are exceptions. I usually work a week to two weeks ahead; so I give preference to shows that are going to be up a long time. If it is a short show—only two weeks—we can do the story early in the artist's studio and have it ready when the show comes up. But I have to have advance notice. Sometimes I don't cover a show just because I wasn't notified soon enough.

I'm not only interested in shows. I look for offbeat stories and angles, like an artist with an unusual life-style or an art school in an unlikely place. I aim for the general reader. I feel a responsibility to help develop an art audience.

Some artists call and try to bully me into writing about them. Usually that only alienates me.

I have never had pressure from the editor in regard to giving coverage to an advertiser.

How should an artist contact you?
Don't bring your paintings into my office and dump them on my desk. Send a press release with a photo; then call me to see if I got the press release and if I need more information. I don't like lengthy phone calls or long, handwritten press releases.

A press release should contain the place, date of the show, the hours it's open, something about the work, and some background on the artist. I like to see a picture of the work—that's what tells me everything. If we want a picture of the artist, we will usually send our own photographer. Your photo should be a good 8″ × 10″ (20 cm × 25 cm), black-and-white glossy, in focus —we cannot use out-of-focus photographs. It should have good contrast; contrast is especially important for newspapers.

It might be good for an artist to bring a press release in person just once, just to see that we are human beings with the phone ringing off the hook and people yelling at us.

Anybody can get into the Friday gallery listings just by typing up your show in a coherent fashion and getting it to me on time.

Sometimes a gallery tells the artist that they will send a press release, and they don't get around to it. The artist should check up to see if they really have sent it.

I want artists to contact me. I am really interested in finding

good art. There is a lot happening that I don't know about, and I want to know.

What should artists know about interviews?
Be there on time for your appointment. A businesslike manner is important.

Our readers are not interested in an abstract philosophical treatise on your work. Don't hand me a three-page theoretical paper. And don't hand me somebody else's article.

I like to interview artists; most artists are pretty verbal. Even artists who think they are non-verbal can talk about their work. It helps to have some of your work there to refer to.

Do you have any other advice for artists?
Read the paper so you'll know what we do.

James Mills, of *The Denver Post*, has worked for Denver's evening paper for twenty-two years and has been the art editor for four years.

What is your job as art editor?
Basically I am responsible for two columns a week, an occasional feature in the Art and Entertainment Section, and other art-related news.

In my columns I cover shows, awards in national and regional juried shows, commissions, new galleries, benefits, and announcements of competitions that are open to Colorado or regional artists. I don't do much with features like the man who has made something out of 7,000 nails or railroad spikes.

I try to expose just as much as I can of what is going on in the area. The Friday column is geared to artists; the Sunday column to the general public.

I could easily fill up more space, but they rarely give me more than one page. Occasionally, if I get down on my hands and knees and beg, I will get a page and a half. Since I've been in Denver, the number of galleries has grown from four or five to ninety or a hundred, but the newspaper has not increased its space for art.

I think of myself as an art reporter rather than an art critic, but

I think my own preferences do show up somewhat—maybe I am more enthusiastic about what I like. I want to help build an art-buying public, to expose them to a variety of things. I want to make them curious and let them see and decide for themselves.

How can an artist get coverage in your paper?
An artist should contact me, preferably in writing; I look at all the press releases that come in. An artist should contact me as much in advance as possible. What goes in my column depends on how much advance notification I have of what is coming up.

I give precedence to major museum shows. I like to cover new galleries of contemporary art, because they have such a hard time making it. I give more space to what I am particularly interested in, but during the year I try to maintain a balance of all kinds of art and art events.

For listings in the Datebook section, just send me the gallery name, address, phone number, and basically what they are featuring. (The Datebook section is a weekly listing of events and activities in the Denver area.)

What should be included in a press release?
The basic facts about the event. If it's a show—where, when, and how long.

Some background on the artist—awards, major shows. Keep to the most important things that have happened to you as an artist.

A general idea of your style, but nothing too technical.

Sometimes I think artists shouldn't verbalize about their work; some do it so badly. Don't try to explain too much. Let the work speak for itself.

I'd be interested in a general description of the work—more media and content, rather than philosophical explanations. As far as technical explanations, unless it was something very unusual, it probably wouldn't be something I would use in a column.

The press release should be one page, maybe two. If you keep it short, the more important facts will stick. It should be typed. I've had some hand-written ones and I couldn't tell how the name was spelled.

Include a phone number. Enclose black-and-white, glossy photographs, no smaller than 5″ × 7″ (13 cm × 18 cm). They have to have sharp contrast. Sometimes even if the photo is not used in the column, it might be used to fill an unexpected spot somewhere else in the paper.

What else should artists know about newspaper coverage?
Artists and galleries should be aware of the newspaper's deadlines; usually a phone call to a receptionist will be able to tell them that. My Sunday column is due the Monday before; the Friday column is due by Wednesday. I have to have all the information well ahead of those deadlines.

Allow as much time as possible. If it can be a month ahead, that's fine. Not less than two weeks.

If it's an organization or group show hoping to get a *Roundup* cover (*Roundup* is the Sunday entertainment magazine), it should be submitted much earlier—as much as six months in advance.

Katharine Chafee, of *The Straight Creek Journal,* is art editor for this weekly that tries "to give in-depth coverage to news events that the dailies are unable to do."

What is your job as art editor?
I think of myself as a critic as well as a journalist. A critic is someone who likes art and can explain why he or she likes or dislikes artwork. Hopefully the critic knows something about art. It is basically opinion. Good criticism is being able to explain how you've arrived at your opinion.

How do you choose what you will review?
I get fifty announcements a week and I have to choose one or two to review. I try to pick the things that are most significant, but sometimes it's just a matter of how they catch the eye. There are some specific things that help me decide:

1. *The timing of a show.* The longer a show runs, the better chance you have of getting publicity. I prefer shows that will be up three to six weeks.

2. *The gallery.* I am more interested if the gallery has a history of having good shows.

3. *The quality of the press release or announcement.* Sometimes I dismiss the art because the announcement is so poorly done. It should be clear and descriptive of the work and the artist. Pictures are very important, but don't send Polaroid or Instamatic snapshots. Phone calls for me are not very useful; I rarely have time to return calls. It's good to know the critic's name and how to spell it, rather than sending your announcement To The Editor or To Whom It May Concern.

4. *Sufficient lead time.* The announcement or press release should be at least two weeks in advance of the show. A press preview is very helpful, that is, inviting the press to see the show three or four days before the opening. I rarely go to openings.

5. *The kind of work.* I like contemporary art and obviously I am most interested in shows that I think are significant in that area. Not that I won't go to a show of western art, but it's harder to get me interested in writing about it.

6. *The quality of work.* There is no point in writing about something that is awful. If I do give a bad review, I try to explain why I think the work is bad. It is usually when I think a good artist is showing disappointing work. I think an artist should hope for at least one bad review during the course of his or her career— that's the only way an artist can grow.

Do you have any other advice for artists?
It is always good to write and thank the critic if you feel the critic has understood your work. The critic likes to feel appreciated.

On Art Editors and Writers in General

In my interviews with art editors I have tried to convey the understanding that they are human beings. They all have some personal bias in their view of art, and they operate under great limitations of time and space, but generally they are sincerely

interested in art and the art community. It is important to understand this so that you can be as helpful as possible and not make unrealistic demands on them. An art editor usually holds that position for several years. So you are probably going to have to deal with that person again and again. From the beginning you should try to develop a friendly, but professional relationship.

Being considerate of press people and appreciative of their help can be incredibly valuable in helping build your career.

By the same token, artists should receive the same respect from reporters. There is a writer who used to cover art news for one of the daily papers. She was notorious for coming to the artist's studio or gallery, conducting lengthy, often hostile, interviews, and then not giving the artist any space in the paper.

There are other reporters who allow their personal prejudices to guide their reporting and some who use their power with the paper in various other unscrupulous ways.

Most press people are pretty honest and straightforward, but if there is a reporter whose ethics you question, ask other artists who have had dealings with the local press. If a reporter dishonestly promises coverage, or is unfair in reviewing work, his or her reputation will spread quickly in the art community. You can complain to the editor or simply look for other sources of publicity.

Know Your Newspapers

Read your local newspapers not just for the news, but study how they present the news. What is the general art focus of the paper? Do they give more coverage to contemporary or traditional work? Do they run regular art columns, and who writes them? Do they give space to critical art reviews? Do they run features on the personalities and life-styles of artists? Do they have regular listings of galleries and shows?

Once you understand how a particular paper handles art news, you will be able to approach that paper more effectively. For instance, if a paper prints only critical reviews of shows, send a simple press release about your exhibit. If they concentrate

more on human interest features about artists, send them more personal information about yourself.

No newspaper can cover every artist and art event, so you have to be patient. If you contact the art editor about one show and there just isn't space for your news, he or she will be more likely to publish your news the next time.

CHAPTER 16

NEWS
OTHER THAN
ART NEWS

Almost any kind of mention in the newspapers is useful publicity for an artist, even if it is not directly related to art. People don't remember where or why they read your name—they just remember that it was in the paper. The more they see your name in the paper, the more likely they are to remember it and to believe that you are someone important.

There is a lot of space for a newspaper to fill with stories every day or week, so the various editors are always looking for news. If something interesting and unusual happens to you, call your local paper. They might think it is newsworthy and write a story about it.

If you are not sure of whom to call at the paper, ask the receptionist. He or she will usually be able to direct you to the right person.

Theft, Protest, Flowers, and a Visit to the Zoo

Following are excerpts from newspaper stories about artists:

ARTIST REPORTS THEFT OF $4,000 PAINTINGS

A Denver artist reported Thursday the theft from his studio of 20 paintings valued at $4,000.

Bob Ragland, recently selected for the 1976 edition of *Who's Who in American Art*, told police the paintings were taken sometime between 6 PM Wednesday and 11 AM Thursday.

Included in the works taken from his studio at 918 E. 23rd Ave. were paintings done under a Jamaican travel

grant and a major piece, *Party Dress.* . . .

"In a way I guess it was kind of flattering," the artist said, "but I'd like the paintings returned."

—*The Denver Post*

ARTIST WAGES PRIVATE WAR WITH IRS, EXPECTS TO WIN

For a year now, Arizona artist Ted de Grazia hasn't painted a picture in a personal protest against the Internal Revenue Service's "double taxation" on living and dying.

"It's my way of telling Uncle Sam what he is doing is not right," the stubborn, outspoken, 68-year-old artist said. "Why should I get punished for having gotten good?"

Last year, De Grazia rode five hours on horseback and burned 100 of his paintings in a ritualistic demonstration in a Superstition Mountain cave to call attention to what he terms "the wrongdoings of the revenuers. . . ."

—Charles Hillinger, *The Denver Post*

BROWN GIVES BACK FLOWER

A metal sculpture of the state's flower, the columbine, was adorning Lt. Gov. George Brown's office Monday.

Less than 24 hours later it had been delivered—by registered mail with $6.13 in postage—to the home of James Roark in Rifle.

Roark, who said he made the sculpture at Brown's request, has been trying to collect $100 for it since delivering it to the lieutenant governor's office 20 months ago. . . .

—*The Rocky Mountain News*

One evening *The Denver Post* ran a photograph of sculptor Ken Bunn at the zoo. The artist was shown modeling a giraffe while a real giraffe looked over his shoulder. The caption read: I think he's got it. The model looks on as Denver sculptor Kenneth R. Bunn puts finishing touches on a wax sculpture of a giraffe. Recent bronzes by the award-winning artist go on view Tuesday in the lobby of the First of Denver Plaza Building, 17th and California Streets. The artworks will be on display through March 4.

Publicity Is Not Accidental

Publicity is rarely accidental. Besides these stories I have seen accounts of new homes built by artists, trips taken by artists, public art programs started by artists—even a spaghetti recipe originated by an artist. None of these stories made their way into the paper by accident. They all began with the artist or the artist's gallery contacting the newspaper. When you contact the paper, be sure to tell them you are an artist and tell them some of your major credentials.

50 Sure-Fire Ways to Get Your Name in the Paper

Following are some suggestions for getting space in newspapers. I have seen articles about people in each of these situations.

1. Receive a large inheritance.
2. Paint a mural.
3. Win a major award.
4. Reject a major award.
5. Donate a painting to a public institution or fund-raising drive.
6. Build an exotic new house or remodel an old one.
7. Conduct a workshop, class, or lecture.
8. Get engaged.
9. Get married.
10. Be a victim of a disaster.
11. Destroy your own work in public protest.
12. Write a book.
13. Write a review of a book, concert, play, or art exhibit.
14. Start a school.
15. Take a trip to an exotic place.
16. Create a recipe.
17. Invent a helpful household hint.
18. Start a museum.
19. Lose your dog.
20. Write a letter to the editor.
21. Get a fellowship or grant.
22. Have a 50th wedding anniversary.

23. Have a 100th birthday.
24. Paint a portrait of a famous person.
25. Buy a sports team.
26. Run for political office.
27. Donate art instruction to a prison, nursing home, or hospital.
28. Sight an unidentified flying object.
29. Become a missing person.
30. Perform a heroic act.
31. Organize a large church or charity function.
32. Win a tennis, bridge, golf, or bowling tournament.
33. Judge an art exhibit.
34. Cut a record.
35. Testify in a public hearing.
36. Sell a piece of work to a public or large corporate collection.
37. Fight city hall.
38. Launch a business venture.
39. Complete a major financial transaction.
40. Declare bankruptcy.
41. Perform in a play or concert.
42. Win a sweepstakes.
43. Grow the biggest pumpkin, the greenest lawn, the prettiest hydrangeas, the longest beard.
44. Organize a historical project.
45. Collect something unusual.
46. Graduate from a university.
47. Live in a haunted house.
48. Host a foreign exchange student.
49. Organize a consumer boycott.
50. Develop a rare disease, preferably not terminal.

Other Newspapers

When you think of newspapers, don't limit yourself to local or metropolitan dailies and weeklies. There are all sorts of newspapers that would be happy to use your press releases and photographs. Suburban, religious, industrial, professional, financial,

organization, university, and ethnic papers—all these are potential sources of publicity for the artist.

Using Publicity

Newspaper publicity can have more uses than just getting your name to the readers of that paper. If an article appears about you that you think will interest your collectors, have the story duplicated and mail it to them. If a favorable review of your work is printed, add it to your portfolio and include copies of it with the material you hand out (brochures, etc.) to people who are interested in your work. Favorable comments from newspaper reviews can be excerpted and used in brochures and invitations. Whatever else you do with newspaper stories, be sure that you save at least one copy for your own personal files.

MAGAZINES AND BOOKS

As a professional artist you should explore every possibility for free publicity. One of the best showcases for artists is the magazine, either art or general interest. Because magazines are visually oriented, they use numerous reproductions, often in full color. A good magazine article can be used in place of a brochure, and it is generally more impressive because it shows the recognition of the artist by the magazine.

The Art Magazine

Every person I've ever talked to who edited or wrote for an art magazine was interested in discovering exciting, new art. They all said they will look at any art or photos of art that are submitted to them. This does not mean that every magazine will publish every kind of art. On the contrary, most art magazines are highly specialized. But within their own fields, they are quite open to the unknown artist who creates original, high-quality art.

What this means is that the first step in getting magazine publicity is to find the right magazine. Start by looking at art magazines. You can find them in libraries, art supply stores, galleries, and large newsstands. Look for those magazines that focus on work that is similar to yours—traditional or contemporary, sculpture, paintings, prints, or crafts.

Then read the magazines carefully; notice where the artists live and show their work. Does the magazine concentrate only on New York artists? Do they focus on regional artists or artists from throughout the United States?

Study the credentials of the artists. Are they all well-estab-

lished, with numerous national awards and museum shows in their resumes, or are some of them "new discoveries?" Are all of the artists dead; do they all have academic backgrounds; do some of them have commercial art backgrounds; are some of them self-taught?

Look carefully at the work. Is the subject matter traditional or avant-garde; is the style classical or contemporary? Is the quality of the work at the same level as yours or higher or lower?

Then read the stories. Do you feel comfortable with the way they are written; is the style too esoteric or too chatty; do the articles talk about things that interest you?

With all these things in mind, pick those magazines that you are most interested in reading and that show the work that is most similar to your own.

How to Contact the Art Magazine

If the magazine is in your area, call the editor. Explain that you are an artist in the area who would like to make an appointment to show him or her your work. Say that you would like to be considered for a feature in the magazine. If you are going to visit a city and want to contact a magazine there, try to make an appointment ahead.

If the editor agrees to see you, take along your portfolio or several good photographs of your work and a resume. Do not take original work unless it is small and easy to carry or unless the editor specifically asks to see original work.

If the magazine isn't located nearby, send about ten very good photographs of your best work and a resume. Enclose a typed letter explaining that you would like to be considered for a feature in the magazine. If you want the photos returned, enclose a stamped, self-addressed envelope.

Sometimes it takes a while for the editor to look at and decide about the work. If you have not heard anything from the magazine within six weeks, write again or call to ask if they received your enquiry.

Who Writes the Story?

If the magazine likes your work, they will generally assign one of their writers to write the story. Many artists have asked me if they would have a better chance of getting into a magazine by submitting a completed story, written by themselves or a friend. I would say that you have a better chance if you do *not* submit a finished story. Each magazine has a definite writing style, and the editors might reject an artist whose work they like just because the story isn't written the way they want it.

In most cases the artist is responsible for providing the photographs. These should be professional quality transparencies or 8″ × 10″ (20.3 cm × 25.4 cm) black and whites. The better the photos you give the magazine, the more likely they are to print them.

Should You Pay for a Magazine Story?

There are some magazines that expect the artist to pay for an article. They might ask the artist to pay the writer's fee or to pay for reproductions. Virtually any artist who is willing to pay can get a story in one of these magazines. You can even buy the front cover.

Other magazines will give articles to major advertisers. If the artist spends enough money on ads, he or she will be assured a story.

Reputable magazines do not sell stories. Their reputation is based on the editorial content of the magazine; if they sell that, they have no integrity left.

I have never paid for a magazine article, and I never would. First of all, I think such publications are unethical; they exploit the artists and the readers. Secondly, if people become aware that you have paid for a magazine story, it makes them think that you are not good enough to be featured by a reputable magazine.

Reviews of Shows

Some magazines devote space to reviews of current exhibitions. If you are interested in such a review, call or write the magazine

to ask for details on how and when they choose the shows they review. (Deadlines are often three months ahead for national magazines.) If it is a national magazine with regional contributing editors, call the representative in your area. This information is contained in the masthead of the magazine.

For instance, Katharine Chafee, the art editor of *The Straight Creek Journal*, also writes for *Art Week*, a magazine published in California. She says, "I'm writing for *Art Week* once a month on Colorado contemporary art. I am free to choose what I want to write about, but they don't always publish what I write. The procedure for getting a review is the same as for a local review. Send a press release. Again be very careful that the release is professional."

Two Editors Describe Their Magazine

Four years ago John Manson and Betty Harvey published the first issue of *Artists of the Rockies*, a thin, but expensively produced quarterly magazine focusing on the art and artists of the Rocky Mountain area. The magazine has not only survived, but it has grown in size and scope. John Manson, editor-publisher, and Betty Harvey, associate editor, talk about their magazine, which is now called *Artists of the Rockies and the Golden West:*

Manson: At first we thought it was going to be a local publication. We didn't realize there would be such wide interest, but people as far away as Texas and California wanted to be included. So we expanded.

We'd like to give a good representation of quality art and artists, past and present. If it's a good artist, we think he or she will be of interest to all our readers.

Harvey: I think we get a little heavy into western art being out here, but we try to get a variety of work. We have a couple of files of potential articles and when we plan each issue, we try to get as much diversity as possible. We try to make each issue as interesting as possible to our readership. We don't want to get stereotyped into one type of art.

We get out and visit the galleries so we can see what's going

on. We have a lot of different people and galleries recommending artists to us. We get an average of three calls a day from artists and stacks of letters.

Manson: We are up to 86 pages now and we have only touched the surface of what we could do, but we have to stay within our budget. We would hate to be producing something we couldn't be proud of.

Harvey: Somewhere along the line we began to realize our responsibility, that when we put someone in our magazine, we are giving our approval to that work. It makes you think twice.

Manson: We look for drawing ability, painting technique, a good basic foundation in art. We like an artist who has developed a style that is uniquely his own.

Harvey: We go to so many shows and so many galleries that the work has to be something exciting, something that will stimulate our readers.

Manson: Putting out a·magazine like this, you become more observant, more demanding of craftsmanship and originality.

And it still has to be a business—you have bills to pay. With an art magazine your production costs can soar. Our income is from subscriptions, retail sales, and advertising, and we have restricted the advertising to gallery-oriented work.

Specific editorial content isn't a determining factor with our advertisers. We do not base our stories on who has bought ads.

Harvey: There have been times when we have been desperate and would have loved to sell a story, but we had to hold out. When you start making deals like that, you lose control of your magazine.

We accept some free-lance articles, but it boils down to the merits of the artist.

When I write a story, it's easier if the artist has some of the background information typed up. I tape-record my interviews. I try to get some kind of feeling for the artist in my stories.

Manson: It is imperative for artists to have excellent examples

of their work in slides and black-and-white photos. We like to see sketches and line drawings as well. We expect the artists to provide photographs. We can't send a photographer out to every artist; it is too costly.

General Interest Magazines

Occasionally a magazine other than an art magazine will run a story about an artist. An artist gets this kind of coverage the same way as any other kind of newspaper or magazine publicity —you contact the editor and convince the person there is something about you or your work that will be of interest to the magazine's readers.

These magazines are rarely interested just in the quality of the work. They look for something unusual about the work or the artist that will be relevant to their particular readers.

The easiest general interest magazines to get coverage in are local or regional magazines. For instance, *Denver, The Denver Magazine,* and *Colorado Magazine* all devote some space to local artists and art happenings. Look for magazines in your area that cover local and regional artists.

However, the possibilities are endless. If you have taken an unusual painting trip, try a travel magazine. If you are over sixty, try a retirement magazine; a feminist artist, a feminist magazine; a black, a black magazine; or a wildlife artist, a wildlife magazine.

Either phone the editor or send a letter stating why you think this magazine should be interested in running a story about you and your artwork.

How to Use Magazine Articles

As I stated earlier, magazine articles are an excellent substitute for brochures. Whenever I have had a feature story appear about my work, I have bought a large number of copies and have given them to collectors and other people interested in my work. (You can usually buy them from the publisher at a substantial reduction.)

If you don't want to send out the entire magazine, you can get permission from the editor to have a commercial printer reprint your story.

If the main focus of the story is on your artwork, and especially if there are reproductions of your work, include the story in your portfolio. Again, be sure to save a copy for your files.

Books

The most substantial form of printed publicity is the book. The most prestigious kind of book about an artist is the monograph, a retrospective account of the artist's life and work. Because of the reproductions, these books are extremely expensive to produce, even in paperback, so publishers choose only well-established artists, often dead, whom they know will attract wide interest.

The *how-to* book is a book that gives instruction for working in a particular style or medium. This is a more likely possibility for the artist who is competent in one or more media and has a unique style, but is not yet considered a ''master.''

Recently Ramon Kelley had such a book published by Watson-Guptill Publications, *Ramon Kelley Paints Portraits and Landscapes* by Ramon Kelley and Mary Carroll Nelson. I asked Ramon how this book came to be.

He explained that when *American Artist* magazine published articles about his work, they asked if they could retain the color reproductions for possible use in books by Watson-Guptill. Ramon thought, if they are interested in using some of my paintings as illustrations for books, maybe they would be interested in publishing a whole book about how I work. So he wrote and asked if Watson-Guptill would consider a book about his work, and the publisher replied they would be very interested.

Meanwhile, Ramon had begun to think of the difficulties in creating a book; he is not a writer and he decided that he could not write a whole book. The publisher resolved that problem easily; they recommended a professional writer to work with Ramon as coauthor. The artist tape-recorded the material he

thought was important for the book, and the writer organized and wrote it.

Ramon told me, "It's a tremendous amount of work, but it really has helped me name-wise. The big thing about a book is that it goes all over—England, Japan, Canada, the United States. All those people will know who Ramon Kelley is and that sells paintings."

Another kind of book is the catalog, which contains a large number of reproductions of an artist's work, usually published by a museum or gallery in conjunction with a major exhibition. Because the work reproduced in the catalog is the same as that in the show, it usually represents a shorter period of time and work than a monograph and it is out-of-date as soon as your work changes. Nevertheless, it can be a very impressive promotional tool, similar to the brochure, but carrying even more weight.

The last kind of book I want to mention is the directory, such as *Who's Who* or *Who's Who in American Art*. The procedure for being included in these directories is, first of all, a nomination. I assume that there are many persons who are authorized to make such nominations, but I do not know who they are. The nominee completes an application, a general biographical form. If the credentials listed in the application meet the standards of the directory, the nominee is listed in the next edition. The publisher usually offers the listed persons the opportunity to buy one or more of the books at a discount, but inclusion in a reputable directory does not depend on your purchase of the book.

There are directories that charge for inclusion. A few years ago I met a woman who was working on a directory of Colorado artists. For only $50, she said, I could have a biography and one reproduction included in the book.

I refuse to pay for listings in books for the same reasons that I refuse to buy articles in magazines. An artist should never have to pay a commercial publisher for the production of a book about the artist; in fact, if the artist contributes to the creation of the book, as a coauthor, for instance, the artist should receive a percentage of the income from sales of the book.

Self-Publishing

Several artists in the Denver area have begun to publish books or catalogs themselves. This involves designing the book, picking out the artwork, finding and working with a printer and distributing the book for sales. This involves a tremendous amount of work, as well as a great expense.

The attraction of self-publishing is that you can publish a book about your work, have complete control of what goes in the book, and if there are any profits, they are all yours.

The disadvantages are, of course, the investment in terms of time, work, and money. Distribution and sales are especially hard for the individual. Also, a self-published book does not receive the same respect as a commercially published book.

Jon Zahourek is one artist who published his own book, *Drawings 1*. It is a 60-page catalog of drawings, $8^{1}/_{2}''$ (21.5 cm) square, with a minimal use of color. He estimates that the 1500 copies cost him $3600. He did all the layout and paste-up work himself, saving an estimated $1700.

He is pleased with the book and glad that he published it. He is now working on his second publication, a book about his paintings.

Following are Jon's comments on his publishing venture:

"Probably the hardest part was picking the drawings. It's so expensive, it really has to last. I was trying to cover ten years—to show where I've been as well as where I am now.

"I spent a lot of time looking at different formats. I felt that a square format gives you the most flexibility as far as horizontal and vertical pictures. And the size I chose works best for mailing and filing. Also, it's comfortable to handle. I wanted a clean, professional presentation and an elegant layout.

"The major difference between a book and a brochure is the number of pages. Even sixty pages on a heavy stock is a minimum for a book. When you're talking about 60 pages, the paper costs really mount up—all your costs mount up. It can be very expensive unless you are doing it all yourself—general design, layout, paste-up. I am lucky that I have some experience in photo-reproduction. Even so, it's a lot of work. I spent nine

months working on the thing—a month-and-a-half, ten hours a day just on paste-up.

"It got out of control in terms of costs. I had started out wanting to do something less expensive. Once you have so much time and work invested in it, it's hard not to pull out all the stops.

"You must approach the printing as seriously as you approach your own work. I shopped very, very carefully for the printer, to get the best possible printer that I could afford. Even with a good printer, you have to be insistent that you get what you have bargained for, the best that you have seen them do. I would estimate I spent more than thirty hours at the printers, talking about plans, working with the cameramen, approving proofs. I spent almost that much time driving back and forth to the printers and at least as much time talking with them on the phone. You can't just hand it over to someone else. If you do, you might get what you want and you might not. You're probably going to be disappointed in the result.

"I was surprised at how hard distribution was. Regular distributors will not handle one book, so I had to contact bookstores myself. It's very difficult to sell even enough to make back the initial investment. I was lucky to get reviews of the book. Some newspapers won't review self-published books.

"I'm glad I did it. It has been a very valuable promotional tool; it has led to many sales of my drawings. It also seems to be working as an introduction, as a proof of professionalism. There are so many hurdles to overcome with people when you represent yourself as an artist. The book is a very succinct proof."

A Warning

Be careful of small, unknown publishers who offer to publish a book for you. They may be reputable, but they may not. Check them out thoroughly before you commit yourself to anything.

There is a phenomenon in publishing known as Vanity Press. These are publishers who will print any book as long as the author is willing to pay the cost. Usually the vanity publisher charges an outrageous price, prints a small number of poor-

quality books, and then refuses to accept any responsibility for promotion and distribution. Avoid them.

There are some small, regional publishers who are reputable and produce quality work. In dealing with these, as well as larger publishers, you should have a written contract that clarifies your arrangement with the publisher. Consult an attorney who is familiar with publishers' contracts before you sign anything. Especially with an unknown publisher, you should demand the right to approve any reproductions of your artwork before publication. A poorly done book and, especially, bad reproductions can do serious harm to your reputation as an artist.

CHAPTER 18

RADIO AND TELEVISION

In pursuing free publicity, do not forget radio and television. Local interview programs are an especially good forum for presenting yourself and your work to a large number of people.

The first step is to find out which stations have interview shows devoted to local affairs and personalities. Call the station to get the name of the person who is in charge of the program. Telephone that person and explain why you think he or she should have you on the show. Usually it is best to call in conjunction with an upcoming exhibit or some other public project or event. If the program director is interested, send a press release and then follow up with another phone call.

Be sure to call several weeks ahead; radio and television shows are booked up well in advance.

About Interview Shows

To get more specific information on radio and television interview shows, I contacted two people who host their own shows.

John Wolfe is program director of Radio Station KVOD, and hosts a daily interview show called "In the Square," a one-hour show in which he talks with artists and other persons who are involved with local events.

What is the focus of your show?
It's unique as far as Denver is concerned because I seek out artists in all of the arts. There are a lot of interview programs on radio and television in Denver, but they don't focus on art, so it's harder for artists to get on them. Any radio show has an

obligation to do community involvement programs. Our programs are more culturally oriented because we are a fine arts radio station and our listeners are interested in art.

How do you choose artists for your show?
Usually I choose them from people who contact me; I don't have time to seek out guests.

I want to be convinced before we go on the show that they have something to say and can be interesting conversationalists. If you are going to have a group exhibit, choose the best conversationalist to be on the radio—not necessarily the best artist.

Usually it's best to have something to get a handle on, like an upcoming show or an artist going into a new style of work. Artists should be advised not to hesitate selling themselves and saying what they are about—I appreciate that.

The best way to get an interview or public service time is knowing someone at the station. If you don't know somebody, maybe your friends do. Everybody on radio and television is inundated with requests. Program directors are more likely to do something for you if you get their attention.

Otherwise, phone the station; call and ask who you should talk with about a potential interview.

What about public service announcements?
Public service announcements are free announcements for non-profit organizations. If the majority of the proceeds from an event are going to a profit-making organization, you are not eligible. This is determined by FCC regulations.

Call before you send in a public service announcement and get a name to send it to. If you make a contact in January, don't assume that the same person will be there in June. This is a very transient business.

How should the artist prepare for the interview?
Send some information ahead of the show: a biography, as brief as possible; an explanation of what kind of work you are doing; and some basic information about the upcoming show. Whatever you send to the station should be done in an orderly manner.

I appreciate seeing some reproductions, photos, or a catalog, but don't bring a bunch of original paintings. There probably won't be room to look at them.

Write out the essential facts to take with you so that you won't forget anything important even if you have only five minutes on the air. But don't go with a written speech, having to read every word—you'll never be invited back again.

There are times when the interviewer is not there by choice. Be prepared for ridiculous, ludicrous, even asinine questions. Don't be thrown off by a hostile interviewer or an interviewer who is not interested in you at all as an artist. Be prepared not to get uptight. Answer every question as calmly and intelligently as you can.

Think, how can I describe my work to someone I can't see and who cannot see me and my work? Use layman's terms. A lot of people don't understand "representational" or "nonobjective," etc. Explain what all that means.

Some people tend to get very nervous. Forget as best you can that you are talking into a microphone or a camera and concentrate on the individual who is asking questions.

Are there things an artist should not do on the air?
Speaking fast is perhaps the worst thing. If they can't see you, they can't understand what you are saying.

Also don't say anything detrimental about other artists. If there's anything that turns me off, it's an artist who says he or she is the only one who's doing anything worthwhile in the area. It doesn't do you any good as far as the public is concerned.

I don't think an artist has to be a huckster. An artist is a natural salesman for his work just by talking about what he's trying to convey and the techniques he uses.

Beverly Martinez of Television Station KWGN, is moderator of "Denver Now," a daily interview show, and affirmative action officer for KWGN.

What is the focus of "Denver Now"?
"Denver Now" started five years ago as a community program concerned with what's going on in Denver. Our purpose is three-

fold: to educate, to inform, and to entertain. We try to give ample time to all segments of the community.

I don't know how many viewers we have, but we now broadcast to seven states on cable television.

How can an artist get time on "Denver Now"?
Most artists are set up by the gallery, but anyone can contact us. Send a press release and follow up with a phone call. We like a formalized request; if you take the time to do that, it makes us think you are serious.

We usually do interviews we can gear around something, some event. Don't just come in and say, "Here I am; I'm an artist."

It comes in by the ton—every kind of request that you can imagine. We look at it all.

What goes on the show is generally a group decision. I do the final programming, so I get to have the final choice. The major thing we consider is what's going on in the city.

What can the artist do to make the interview more successful?
Submit a biography ahead; emphasize the high points of your career. If your medium is unusual, it is interesting to show how it is done. For television it is better to bring in actual work rather than slides. Never wear white on television. Aside from that, wear what's comfortable for you. It can and should be a very relaxed situation. Think of it as a conversation with the interviewer. Even people who are very nervous at first usually enjoy being on television so much that they want to come back.

Are there other possibilities of television coverage for artists?
Almost every station has one public affairs program. There are various ethnic programs an artist might be able to fit into. You could try the news department if you have something that might be a news story. Also there are public service announcements for non-profit organizations.

Some Suggestions about Interviews

Here are a few things to keep in mind if you are ever interviewed.

1. *Be on time.* It is always important to be punctual; this tells people that you are a professional. If you are late for a television or radio broadcast, especially a live one, you will probably lose your spot on the show. Ask what time you should be at the studio and be sure you know where the studio is. Sometimes you will be asked to come early—this is for your benefit as well as the interviewer's. It gives you a chance to meet each other; it gives you time to become acquainted with the surroundings; and it gives you an opportunity to ask any questions that you may have about the broadcast.

2. *Do not be embarrassed to ask questions ahead of time.* Ask if it will be a live or taped broadcast; if you should bring some work with you; how close you should sit to the microphone; if you should look at the moderator or at the camera; how much time you will have to talk—whatever you are not sure of.

3. *Remember why you are there.* Probably you are there to promote a particular exhibit, so talk about that exhibit. Give all the facts—where, when, how long—and say what is interesting or unusual about the show. Maybe you will have plenty of time to chat with the moderator on the show, but you might just have a few minutes. Use whatever time you have to promote your work. That is why you are there, to tell people that you are having a show and that you want them to come to it.

4. *Be enthusiastic about your work.* You must be somewhat pleased and excited about your art or you wouldn't go to all the trouble of exhibiting it—don't be shy about sharing those feelings. The very best way to get other people interested in what you are doing is to share your enthusiasm about that work.

The News Department

The news department of a radio or television station is often completely independent in its programming. You should consider the news department an additional source of publicity, because they create feature programs as well as regular news broadcasts.

For instance, John Neal, of the news staff of television station KOA-TV, produces "Scope," a half-hour weekly feature show about an interesting person or event. He says, "I get my subjects mostly from newspaper clippings, phone calls, and references from other people. Often it's whatever I can conveniently get to that week. About one in five shows deals with art-related subjects. I ask myself, would I be interested in this if I were a viewer?

"I have a hard time dealing with phone calls and hastily jotted notes. If you have a suggestion for a show, put it on paper."

John Neal, who is also a regular news broadcaster, suggests that if you have a special art event, it's worth contacting the news department for possible coverage on a news show. He says, "Call the news department and find out who is the right person to contact. Send your information to that person; otherwise it might end up in a trash can."

In the section about newspapers, I quoted a story about a burglary of an artist's studio. Bob Ragland, the victim of the crime, got news coverage on television as well as in the papers by calling the television stations as well as the newspaper offices.

Public Radio and Television

Non-commercial, public broadcasting stations are usually more receptive to artists than other radio and television stations. They are often more culturally oriented than commercial stations and less rigid in their programming. If you have an upcoming exhibit or other art event, if you are working in an unusual style or medium, or if you just have an idea for an art-related program, your best chance for a favorable response is probably with a public radio or television station.

CHAPTER 19

PAID
ADVERTISING

Before I get into the specific details of paid advertising, I think it would be helpful to discuss the general purpose that it serves. Creating art is a solitary occupation—you could spend your whole life creating art in absolute privacy. Marketing art, on the other hand, depends on communication with the public. You have to make people aware that you have produced this art, and that by buying your art they will enrich their lives.

Everything in this book is directed toward that end, but paid advertising is the most obvious means to achieve it. To create public awareness of yourself and your art, there are three major concepts that you must include in your promotion. The first and most important is to establish your credibility as a professional artist. Although there are many ways you can develop this professional image in your personal dealings with people, to convince the public that you are a professional artist, you must rely on advertising, free and paid.

Ironically, the worst way to convey this image is to say in print or through other media, "I am a professional artist." It is best to imply it. Advertise those things about yourself that demonstrate your professionalism. For example, publishing reproductions of your work establishes that you are a professional. Announcing an exhibit or your affiliation with a professional gallery does the same thing.

Once you establish your name as a professional, the next step is to convince people that your work is good. Most important is showing your work in a professional manner, which in most cases means having excellent photographs made of your best work. In addition, it is good to make people aware of your

awards and other credentials and to publish endorsements of your work by art authorities. (See Chapter Three, Getting Someone Else to Write about Your Work, for information about endorsements.)

Finally, you want to help people decide to buy your work. With each kind of art, there are some people who will like it and some who won't. Advertising can help establish an awareness of your work among those people who will appreciate it.

Many collectors resist work that is unusual. They might like it, but will still be afraid to buy it. Continued exposure to a new or unusual kind of art, through reproductions in articles and ads, can help the collector feel more comfortable with that work.

The simplest and most effective marketing technique is repeated exposure. Expose the public to your name and your work over and over again. Sooner or later they will believe that you are an important artist who does significant work. There are many variations and refinements, but with this basic approach of continued exposure you can go a long way toward professional success as an artist.

Advertising an Exhibit—Invitations

Whether you are planning an advertising program for a single exhibit or developing a plan of promotion for your entire career, the first step is to decide what you want your advertising to accomplish. With a show it is simple: first of all, you want people to attend your exhibit and, secondly, you want them to buy your work.

For most artists, the best form of paid advertising for an exhibit is direct mail advertising. This includes invitations and announcements that are mailed directly to each potential collector. (See Chapter Six for information on developing a mailing list and Chapter Seven for planning and mailing invitations to an exhibit.)

The power of direct mail advertising is that you can reach specific people with your message. Your invitation goes directly to each collector, so you know that that person will be informed

of your show. Plus, the collector will have a tangible reminder of the exhibit.

The primary consideration in planning an invitation or announcement is how much money you have to spend. You will have to allow for printing costs (see Chapter Four for information on dealing with printers) and postage. I feel that the invitation is the single most important piece of promotion you need for a show and even if you have only a small amount of money, use it all to produce a substantial invitation.

The invitation should contain: (1) all of the facts about the show—the artist's name, gallery name, address, date and hours of the reception, dates and hours of the show, and the medium and subject matter; (2) at least one example of the work that will be exhibited; and (3) a statement inviting the recipient to attend. If there is space in your format without crowding the invitation, add a brief resume of the artist's career and/or a short endorsement of the work by an art authority.

As with all your printed material, use professional quality printing, heavy paper, and a simple design.

An announcement of a show is similar, but does not contain a statement inviting the recipient to attend. I think it is less effective because it is less personal. If you have enough money, you might consider sending invitations to the reception, followed by general announcements of the show, or vice versa. This gives the individuals on your mailing list a double reminder of the exhibit. Announcements are also good for posting in public places—bulletin boards and windows of stores, schools, museums, libraries.

One artist I know sent announcements to new people on his mailing list telling them that they would be receiving invitations to his upcoming exhibit.

If you are having an exhibit in conjunction with a gallery or other institution, it is better to write the invitation as though it comes from the gallery rather than from you. This creates a stronger impression that the gallery endorses the artist's work.

Other Advertising for an Exhibit

The more often a collector is reminded of an exhibit, the more likely he or she is to attend. This is why it is good to repeat your announcement in public advertisements. Also, public advertisements may reach collectors who are not on your mailing list. How do you decide what kinds of ad space to buy?

First make a list of all the possibilities: newspapers, magazines, television, radio, posters—any way of reaching a large, general audience. Then consider each item on your list, for instance:

Newspapers. Newspapers are widely read. Though many regular newspaper readers are not interested in art, it is possible to specify that your ad be run in the art section of the newspaper, perhaps near a regular art column or in the weekend art and entertainment magazine. Since newspapers are a visual medium, your ad can include a reproduction. However, because of poor quality printing, you are limited to showing a piece that has high contrast and will look good in black and white. Because newspapers are published frequently, you can choose the most strategic time for your ad, e.g., the morning or evening of your reception. Also, you do not have to commit yourself to an ad as far in advance as with other media.

Magazines. Magazine ads are more expensive than newspaper ads, but generally they reach a more specific audience and the quality of reproduction is finer. It is essential to consider which particular ones will be most effective. For instance, an art magazine that is read by collectors will probably do more good than a magazine read only by other artists. Similarly an art magazine that shows work compatible with yours will be the best showcase for your ad; spending money to advertise your nonobjective constructions of plaster and feathers in a magazine devoted to classical sculpture probably would not help you at all.

As for non-art magazines, it is best to choose a publication whose readers will be interested in your work for a special reason. For example, if you paint wildlife, you might advertise your

exhibit in an outdoor magazine. If you create erotic sculpture, you might consider *Playboy* or *Penthouse*.

If your sole interest in buying ad space is to get viewers to attend your exhibit, you probably should concentrate on local publications. If you want to create the impression that your work is of national interest, an ad in a national magazine might be worthwhile.

Television. Television has an enormous impact on the buying public of America. However, it is most effective if it is used in a large way, i.e., a major advertising campaign of numerous commercials on several stations at many times during the day. This kind of advertising represents a tremendous financial investment, beyond the budget of most artists.

Radio. Radio has the same sense of immediacy as television and it is less expensive. However, it is a non-visual medium. Your message has to be verbal; there is no way to show people your work on radio.

Posters. Posters can be an effective and relatively inexpensive advertising tool. The big problem with posters is the great amount of time and effort it can take to find highly visible places where you will be allowed to hang them.

After you have considered the general kinds of advertising available to you, it is time to research the particular sources. Pick out several specific newspapers, magazines, radio and television stations and phone their advertising departments. Ask about their rates—how much do they charge for how much space or time? Can they guarantee that your ad will appear on a particular page or at a particular time? How many readers or viewers do they have? What are their readers like—age, profession, interests, location? When are their deadlines for buying ads? When do you have to pay for the ad? With this information and with an awareness of your own budget, you can now decide where and how to advertise.

An Example

To make this more specific, let us take an example of an advertising plan. I am planning a one-woman exhibit, and have $300 that I can spend on promotion which my gallery is willing to match. So I have a total budget of $600.

My first concern is the invitation. I have found a printer who will produce 700 black-and-white invitations with one reproduction on a good, heavy paper for about $90. Postage will be about $90 also. So that leaves me with $420 for other advertising.

I start with a list of media I might like to use, newspapers, magazines, radio, and television. Then I pick out specific ones to call for their advertising rates. (The following information is valid for August, 1977, in Denver.)
First, some newspapers:

The Rocky Mountain News. The *News* is Denver's daily morning paper. For "display ads" (as distinguished from classified or want ads) they charge by the column-inch, i.e., a space one column wide and one inch long costs $14.70 daily. This rate is the same for every day of the week and any space within the paper. An ad that would be large enough to include a good-sized reproduction would be two columns × four inches or eight column-inches, $117.60. The circulation of the *News* is 246,000 daily and 266,500 Sunday.

The Denver Post. The *Post* is Denver's daily evening paper. One column-inch is $14.49 daily or $15.82 Sunday. An eight-column-inch ad would cost $115.92 or $126.56. Their circulation is 260,-000 daily and 340,000 Sunday.

The Straight Creek Journal. This is a weekly paper with an estimated readership of 15,000. The last survey of readers showed that 72% were between the ages of 21–35; 31% earn over $12,000; and 89% have some college education. The rates are $3.50 per column-inch or $36 for an eight-column-inch ad.

Next, some magazines:

Denver. Denver is a monthly metropolitan magazine with a circu-

lation of 24,000. For a ¹/₃ page ad in black and white they charge $446.40, in color $537.40.

The Denver Magazine. This is a monthly metropolitan magazine with over 15,000 paid subscribers. Their emphasis on cultural events is greater than *Denver's*, so their readers would more likely be interested in an art exhibit. A ¹/₃ page ad in black and white costs $205, in color $375.

The Art Connection (contained in *The Colorado Visitor Review*). This small-format magazine is distributed free to hotels, convention centers, restaurants, etc. Some 20,000 are printed monthly. *The Art Connection* is a guide to galleries and other art services in Colorado. Their minimum display ad is one column-inch for $37.50. A full page (4³/₄″ × 7¹/₂″) in black and white is $395.

Artists of the Rockies and the Golden West. This is a regional art magazine published quarterly. They estimate a circulation of 15,000 retail and subscription sales. For ¹/₄ page black and white they charge $180, color $225; for ¹/₃ page black and white $245, color $295.

American Artist. This is a monthly national magazine. It has a circulation of 119,962, but most of these readers are artists rather than collectors. For ¹/₄ page black and white they charge $872, for color $1,347; for ¹/₃ page black and white $1,126, for color $1,601.

Art News. This is a monthly national magazine with a circulation of 41,319, consisting of a more general selection of readers from the art world. For ¹/₆ page black and white they charge $220; for ¹/₃ page black and white, $395. Full color full page ads are $1,585.

Two radio stations:

KVOD. This is a fine arts station that estimates 100,000 different listeners during the course of a week. It is a smaller audience than some Denver stations, but the listeners are more likely to be interested in an art exhibit. They charge $12–$16.75 for 30 seconds depending on the time of day.

KHOW. This is a popular radio station that claims 25,000 listeners, aged 18–49, during their peak hours, 6–10 AM. They charge $48–$91 for 30 seconds depending on the time of day.

A television station:

KBTV. This is the Denver affiliate of the American Broadcasting Company. They charge $25–$1,650 for 30 seconds depending on the time and programming. This does not include the costs of producing a television commercial.

As you can see, advertising is tremendously expensive and considering the various ad rates, I realize that my $420 will not buy very much.

Since I want people to attend my exhibit, my first step is to eliminate those ads that would seem to be the least effective for my purposes. I eliminate radio and television because only the people who are listening or viewing during my thirty seconds, a very short time, will be exposed to the information about my show. With the printed media, my ad will be available for at least one full day in a newspaper and for as long as three months in a quarterly magazine. Also the paper or magazine provides a tangible reminder of my show.

Next I eliminate the national publications. I have talked with a large number of artists and dealers and they agree that the response to ads in national magazines is rarely immediate, it rarely affects the attendance at a particular exhibit in Denver. (The one major exception is when the ad accompanies a major feature article about the artist.)

Of the local publications, the ones that offer the widest exposure for the least amount of money are the newspapers. I can have one eight-column-inch ad in all three papers to coincide with the reception of my show for $269.52. Up to 521,000 people will see the notification of my exhibit including a reproduction of my work.

This leaves me with $150.48. With this I will buy smaller newspaper ads for the additional two weeks of my show. One ad, two-column-inches, in each Sunday paper for the second and third weeks of my show, plus two additional ads of the same size in *Straight Creek* will cost $136.08.

My costs for producing the ads are minimal. I already have 8″ ×10″ photographs of my work and I can do my own ad design. I may have to spend $10–$15 to have some type set.

With my invitations this is a total advertising expenditure of $600. For my money 700 people will receive personal invitations to my show. Up to 521,000 people will see public announcements on the day that the show opens, followed by two weekly reminders.

How to Place Your Ad

Call or visit the advertising department where you want to place your ad to confirm the details of price, size, deadline, etc. Ask them any questions you have about the form of your ad. When you have made your final decisions, notify the advertising representative. Be sure that he or she understands and agrees to your specifications, date, size, location, and format. If you are purchasing more than one ad, ask about special rates.

How to Design Your Ad

The same rules apply as to any other printing design—keep it simple and direct. Always include the basic information—artist's name, gallery name and address, dates and hours, and medium and subject if important. Use photographs of work whenever possible. (Do not use reproductions if their size is so small that it is difficult to see them.) Any non-essential information should be left out unless you have a large space, and even then, the simplest ad is usually the most effective. People will rarely take the time to read a lot of text in an ad.

For help with radio and television ads, talk with the advertising representatives of the station that is selling you the air time. They should be happy to help.

Free Publicity for Your Exhibit

In planning an advertising program do not forget the possibilities for free publicity—use free and paid publicity to complement

each other. If, for instance, your work is being featured in a magazine at the same time as your show, consider buying an ad in that issue of the magazine. The readers will be especially interested in the show because of the article about you.

Keep in mind that the more often people are reminded of your show, the more likely they are to attend. Explore every possibility of free and paid promotion for your exhibit.

Using Advertising for General Sales and Exposure

At some point in your career you might decide that you need more public exposure. Maybe your work isn't selling as well as it should or maybe you would just like more public awareness of your work. Maybe you have established a strong local success, but you would like a national audience.

Publicity, free and paid, can help to accomplish these and other goals. Again, you must first decide what your goal is. Then plan your approach as specifically as you would for an exhibit.

There is one southwestern artist who, after years of relative obscurity, decided he was ready for national recognition. The story is that he signed a contract with a major national art magazine, purchasing a year of monthly, full-color, full-page ads for his work. It was a gamble for the artist who didn't have anywhere near the $10,000 he had agreed to pay. The ads ran for several months and nothing happened. Then toward the end of the year, collectors and galleries began to respond to his ads. Today he is one of the hottest successes in America.

Why would this work? First of all, such wide exposure would help the artist reach the collectors and galleries throughout the United States who would appreciate his work. Secondly, such large, affluent-looking ads, repeated month after month, would convince the art public that this artist must be very important and very successful.

In order to achieve such a coup de grace, the artist must be willing to make a major commitment; advertising involves a large financial investment. In August, 1977, a full-color, full-page ad in *Art in America* cost $1,615; in *Art News* $1,585; in *Artforum* (black and white) $850. Just one ad is not enough to

achieve important results. The larger the number of ads, the greater the probability of success.

Similarly with free publicity, the artist must be willing to make a major commitment. Just one article in a newspaper or magazine will not have a significant effect on your career, but ten or twelve articles in major magazines and newspapers—that is enough to convince people that you are an important artist. Getting ten or twelve free articles, even in small publications, requires the investment of a tremendous amount of time and effort.

There is no guarantee that any form of promotion will be successful. As you try different approaches, you can do your own marketing research—ask collectors how they heard about you and why they came to your show. Essentially, though, promotion has to be an act of faith. You have to believe that if you keep creating art and keep promoting that art, eventually you will be successful.

You must believe in yourself and your work. You must be willing to invest in yourself and your work. The greater your commitment is to your art career, the greater your rewards will be.

CONCLUSION

One of the most difficult tasks artists face is achieving a balance between creating and promoting their art. If an artist devotes too much energy to creating art, neglecting promotion, the artist faces a career of financial frustration. If the artist gets carried away with promotion, ignoring the need to grow as a creative artist, he or she faces great personal frustration.

For each person there is a balance, but no one can tell you how to achieve it. You must keep asking yourself, am I happy as an artist and am I achieving what is important to me? If your answers to the questions are negative, you must analyze your life and work. Be very honest with yourself and be willing to change the pattern of your career.

Is there ever too much publicity? I don't think so. Artists today should think of the whole world as their marketplace. There are art buyers in every part of the world and until you reach every one of them, you have not saturated the market.

I do think it is important not to concentrate all of your promotion in one area. When you have achieved a reasonable success in your own community, enlarge your goals. Begin to promote your work state-wide, then throughout a whole region of the country, then to all of the United States and beyond.

Is any publicity bad for your career? In general, I would say no. People have short memories; they remember hearing about an artist, but they don't often remember what they heard.

However, each artist must be comfortable with his or her own publicity. It is a matter of personal taste. It is best not to engage in any kind of publicity that you find personally offensive. It might not have a negative effect on the public, but if it makes

you feel bad about yourself or your work, it is best to avoid it.

There are artists who like to pretend that they are not business people. They either hide their business dealings or treat them as dirty but necessary chores. My own feeling is that it is exciting and gratifying to learn to control the business aspects of my career. The more competent and independent I become, the more freedom I feel, and this seems to affect every aspect of my art.

The artist who turns up his or her nose at business is like the Victorian lady with her disdain of sex. Whether you admit it or not, it is still there and it very much affects your life. You might as well smile and enjoy it.

SUGGESTED READING

American Artist Business Letter. New York: Billboard Publications, Inc.

Associated Councils of the Arts. *The Visual Artist and the Law*. New York: Praeger, 1974

Chamberlain, Betty. *The Artist's Guide to His Market*. 2d rev. ed. New York: Watson-Guptill Publications, 1975

Cochrane, Diane. *This Business of Art*. New York: Watson-Guptill Publications, 1978

Cummings, Paul, ed. *Fine Arts Marketplace*. 3rd ed. New York: R. R. Bowker, 1977

Goodman, Calvin J., *Marketing Art*. Los Angeles: Gee Tee Books, 1976

——. *A Handbook for Artists and Art Dealers*. Los Angeles: Gee Tee Books, 1977

Harris, Kenneth. *How to Make a Living as a Painter*. rev. ed. New York: Watson-Guptill Publications, 1964

Holden, Donald. *Art Career Guide*. 3rd rev. ed. New York: Watson-Guptill Publications, 1973

INDEX

Edited by Donna Wilkinson
Designed by Bob Fillie